FOUNDation

Transforming
Found Objects
into
Digital Assemblage

FOUNDation

Transforming
Found Objects
into
Digital Assemblage

Spencer Drate

Watson-Guptill Publications/New York

Notes on the Art

Page iii, top to bottom: *Blue Gravy: Phase 9 CD packaging* (detail), TWO: design; *Tea Tin* (detail), Michael Garson

Page iv: *Pearl Jam Fan Club Newsletter #14* (detail), Ames Design

Page v, bottom: *The Careful Reader* (detail), Charles Wilkin

Pages vi: *Tête-à-Tête Typo Kit* (detail), Creamo1 Federation

Page vii, top to bottom: *Atari: RE:cycled Icon*, Zinzell; *Hair* (detail), Maria Gaviria

Pages viii–ix: *Dodge Magazine* (detail), Graphic Havoc: avisualagency

Page x, top to bottom: *DV (series)* (detail), Slow Hearth Studio; *Abductions and Reconstructions CD packaging* (detail), Ashby Design

Page 1: *Madison Plunkert birth announcement* (detail), Spur Design

Page 2, clockwise from top left: *Container* (detail), Zinzell; *Chunk EPS set* (detail), Carlos Segura; *Error EPS set* (detail), Carlos Segura

Page 3, top to bottom: *Slicker: Remixes LP*, Graphic Havoc: avisualagency; *Chunk EPS set* (detail), Carlos Segura

Page 4: *Peepod EPS set* (detail), Carlos Segura

Page 5, top to bottom: *Container* (detail), Zinzell; *Construction Field* (detail), Creamo1 Federation

Pages 6–7, clockwise from top left: *Peepod EPS set* (detail), Carlos Segura; *Possessed: The Rise and Fall of Prince book cover* (detail), Jütka Salavetz; *Chunk EPS set* (detail), Carlos Segura; *DV (series)* (detail), Slow Hearth Studio

Copyright © 2003 by Spencer Drate

First published in 2003 by Watson-Guptill Publications,
a division of VNU Business Media, Inc.,
770 Broadway, New York, N.Y. 10003
www.watsonguptill.com

Library of Congress Cataloging-in-Publication Data

Drate. Spencer.
 Foundation : transforming found objects into digital assemblage / Spencer Drate.
 p. cm.
Includes index.
 ISBN 0-8230-1295-6
1. Found objects (Art) 2. Assemblage (Art) 3. Image
processing--Digital techniques. 4. Arts, Modern--20th century. I.
Title.
 N6494.F6D73 2003
 702'.8'14--dc21 2002155519

Senior Editor, Acquisition: *Alison Hagge*
Senior Editor: *Julie Mazur*
Art direction/Design: *Judith Salavetz*
Cover design: *Don Zinzell*
Production Manager: *Ellen Greene*
The principal typefaces used in the composition of this book were 9-point FC-Egyptian505-Rmn and 8-point Interstate-Light.

Manufactured in Singapore

First printing, 2003

1 2 3 4 5 6 7 8 / 10 09 08 07 06 05 04 03

Dedication

This book is dedicated to the spirit and inspiration of Justin, Ariel, and their mom.

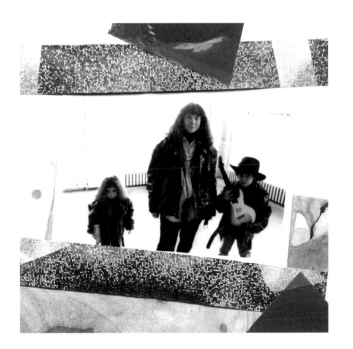

Table of Contents

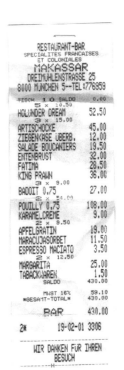

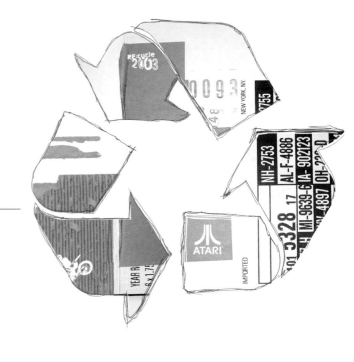

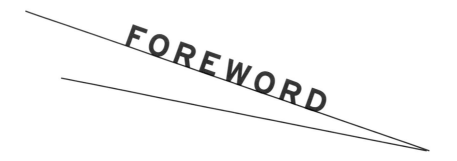

FOREWORD

My largest "find" to date? My career.

The assumption is always that a career is a by-product of years of education and planning, but the truth is that I have neither. My "education" has come from real-world experience, which in many fields is actually better than schoolhouse training. And the "planning" has been simply a result of curiosity, which, in essence, has served as a replacement for formal training and education.

"Found" objects aren't found at all. They are discovered. For the most part, "creatives" tend to discover more because we are always looking for something that most others feel is not even there. Taking things for granted is perhaps the biggest sin we commit, and this constant search within our surroundings can be an enhancement to everyday life that is quite rewarding on a variety of levels.

Curiosity is something we all hope to have, and we all do have it to a certain extent. Some of us only exercise it when prodded by a question or experience, while others use it to drive ourselves to expand our lives.

I was once in New York with a client doing a film, and as we walked from one location to another, I noticed a manhole cover in the middle of an intersection. I was surrounded by hundreds of people, all

wanting to get to the other side as quickly as possible. As I was walking next to my client at a considerably slower pace, I stopped in the middle of the street and started shooting the cover with my camera (which I take with me everywhere). You should have seen the look on his (and everyone else's) face. "What the hell are you doing?" he asked. After explaining the obvious to him, he said, "Carlos, this is why you are who you are and why you're so good

I said, "Because it read 'New York City Sewer' at the top and 'Made in China' at the bottom." He responded, "How did you even see that?" I could not begin to try to explain. But it happens all the time. What a wonderful thing.

Carlos Segura
Segura Inc.,
Segura Interactive, and [T-26]

at it." I asked him if he'd noticed what I'd just been photographing. He hadn't, of course, because he'd been focusing on my behavior. When I told him I had just photographed a manhole cover, he immediately asked "Why?"

Acknowledgments

Thank you to Alison Hagge (who saw the vision), Julie Mazur (who completed the vision), all of the people at Watson-Guptill, Jütka Salavetz (the grand designer), Carlos Segura (the type-master), Don Zinzell (the wunderkind), Scott Clum (the seed of the idea), all of the other people who contributed to the book, and all of the found objects in the book.

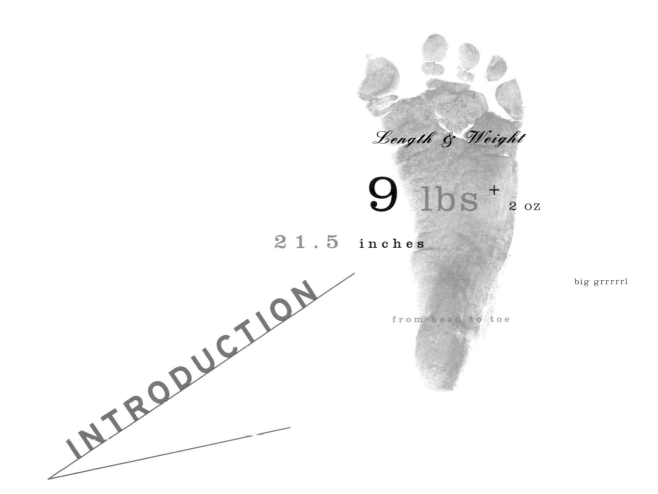

Length & Weight

9 lbs ⁺ 2 OZ

2 1 . 5 inches

big grrrrrl

from head to toe

INTRODUCTION

Born out of post-Industrial Revolution excess, found objects capitalize on human sentiment and the discarded exploitations of consumerism and technology. The medium of found objects is one of irony, built from commercial ideals and dismantled by the emotional tangles of artistic expression.

Found objects are nostalgia, the familiar and the forgotten remains of modern living. Artists like Marcel Duchamp, Kurt Schwitters, Robert Rauschenberg, Joseph Cornell, and Andy Warhol have immortalized everyday objects by forcing the viewer to find new meaning in the obvious, carefully exposing the delicate balance between the conscious and unconscious. It is this juxtaposition that visually confronts the meaning of our commercial endeavors while embracing our very beings. Perhaps this is why, after almost one hundred years, found objects continue to infatuate, inspire, and influence human culture, saturating the mainstream and contemporary graphic design with their ideals, aesthetics, and contradictions. As we try to make this alienating new age our own—full as it is with new media, multi-tasking, and visual overload—

designers cross over into personal expression, exploiting technology for its freedoms while exploring the humanistic qualities

accidenbt.

of found objects as comforting links to where we have been.

Historically, graphic design has looked to art for inspiration and, in many ways, guidance. I am sure this is why many designers are more familiar with Kurt Schwitters' *Merz* publication and typographic experiments than his found-object collages. Perhaps this is also why Robert Rauschenberg's layered assemblage *Story* feels so

contemporary, and why Andy Warhol's screenprint of a Campbell's soup can still resonates. Or is it simply that technology, design, and our social aesthetic have finally caught up with these innovators? Possibly it's a combination of both.

In the 1980s, with the accessibility of the photocopy machine, the punk flyer vernacular was born, laying the foundation for what would become known as "grunge" in the 1990s. This kind of visual and social evolution through technology is evident throughout history. More specifically, we can trace the influence of found objects from one art movement to another. From Cubism to Dada

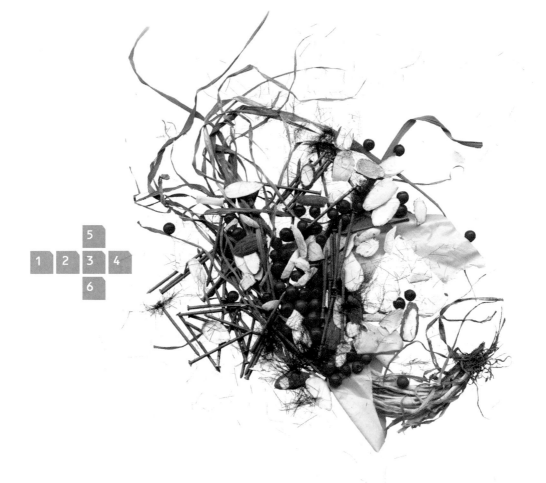

to Surrealism to Pop Art, found objects have played a major role in defining these movements.

While Georges Braque was the first to experiment with found objects in 1912, it was Juan Gris, a Cubist, who first exhibited the use of this new medium in 1914, with his painting *Breakfast*. To Gris, the inclusion of familiar found objects, in this case scraps of wallpaper and newspaper, forced reality and nonreality to coexist, further exaggerating his Cubist ideals of breaking down form into linear planes of abstract space. More importantly, Gris's experimental use of found objects opened the door for artists to reexamine not only the very nature of art-making, but also the social changes and materialistic ideals created by the Industrial Revolution.

It was not, however, until 1917, when Dadaist Marcel Duchamp's *Fountain* was rejected from a Society of Independent Artists' exhibition in New York City, that this dramatic change in art-making redefined our social consciousness of the found object. Duchamp's use of a commercially manufactured urinal, with its ironic associations, defied tradition and challenged the accepted expectations of art and art-making. The controversy created by this piece pushed found objects to

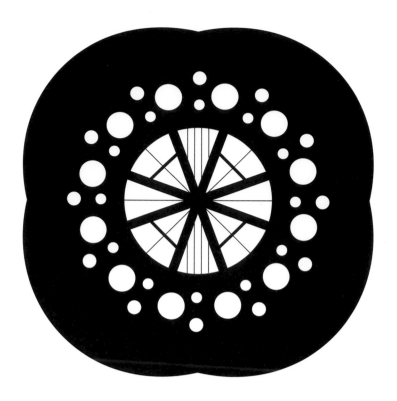

the forefront of art-making, transforming them from simple everyday objects into icons of modern culture. Duchamp's disregard for tradition paved the way for future artists like Surrealist Joseph Cornell, who carefully preserved the innocence and honesty of human sentimentality in his boxes, such as *Untitled (Hotel Eden)*, and fellow Dadaist Hannah Höch, whose photomontages explored very early feminist ideas.

If the old phrase "life imitates art and art imitates life" is really just a metaphor for the change created by technology and capitalism, then it's easy to see why found objects have become so influential in not only art and design, but also society. The invention of the printing press launched technology and personal expression into an irreversibly codependent cycle shaped by personal expression that continues to redefine society and the development of commercial design today. It's not surprising that design's precarious position in this cycle, somewhere between art and commerce, often makes it vulnerable to the fluctuations of this intrinsic contrast.

It has become obvious in this post-modern age of digital everything that America's voyeuristic infatuation with reality television, nostalgia ("retro"), recycling, and rapid communication has put design in a new and

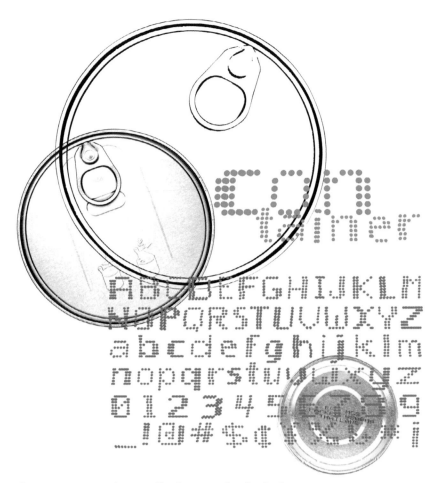

somewhat tenuous context. Our longing for the familiar and our consequential fascination with found objects has inadvertently transformed us into a society consumed with the idyllically mundane. I believe that this ironic notion is ultimately what makes many of us historians, collectors, and cultivators of pop culture, both past and present. As members of society in these ever-changing times, we strive to connect with the familiar in the hopes of making it our own. This cultural shift has unavoidably forced design to become the new voice of commerce and the vision of our instinctual desires. As designers, our use of found objects has not only become a "supply on demand" of society's ideals, but a juxtaposition of capitalism and individual expression. This emotionally charged combination is essentially what makes found objects "happen," while providing us a reference point for the future by merging past with present. This delicate contrast between what we know and what we feel is ultimately what gives found objects— and graphic design—the power to continually challenge, define, and reshape society.

Charles Wilkin
Automatic Art and Design

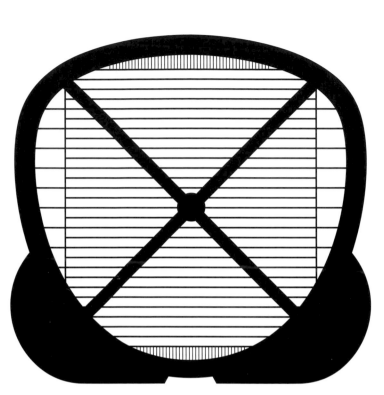

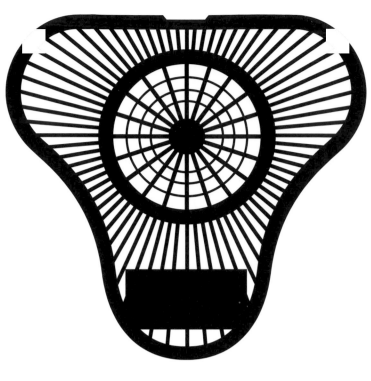

THIS AREA TRIMS OUT

PABLO A. MEDINA received a B.F.A. in painting and drawing and an M.S. in communication design from Pratt Institute, where his master's thesis project led him to design a series of alphabets based on signage he'd observed in Latin American neighborhoods in and around New York City. His work has appeared in several publications, including *HOW*, *Idea*, *Communication Arts Online*, and *Upper & Lowercase* magazines, and *Extreme Fonts* (Madison Square Press, 1999). He has taught at Maryland Institute College of Art and presently serves as professor of design and typography at Parsons School of Design .

In 2001, Medina launched Cubanica, an experimental art and design studio and font foundry dedicated to the explo-

ration and interpretation of culture. Cubanica has had work exhibited in the Design Triennial Show at the Cooper-Hewitt National Design Museum, the Art Directors Club's Young Guns III biennial, and AIGA's Face Off exhibition. Some of Cubanica's clients include the Museum of Modern Art, Cyclops Productions, HarperCollins Publishers, *Teen People* magazine, *ESPN* magazine, the National Hockey League, and the Art Directors Club.

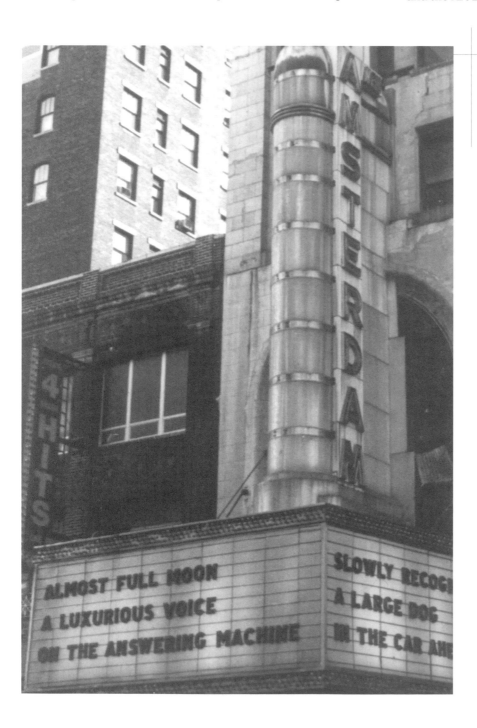

Marquee

In 1979, I talked my mom into seeing the karate movie *Kill or Be Killed*. It was playing at an old theater on New York's 42nd Street, where pornos alternated with martial arts flicks. When the lights came up after the movie, her purse had been stolen.

Ten years later, in art school, I found myself still fascinated by that street of lights. Biking from Brooklyn, I would bring my camera and try to capture the images and feelings that I found so compelling. Times Square was really raw then. It was this weird mixture of hypnotic advertising and alluring sin. It engulfed all of the senses. It was a hallucinogenic drug for the eyes and an alarm clock for the emotions.

On one of my many visits to Times Square, I took a picture of a movie marquee that was part of a public art project called *Haiku on 42nd Street*. The project installed short poems on the abandoned theater marquees that had once advertised *Enter the Dragon* and *Debbie Does Dallas*. This poem, written by Alexis Rosella, was on the marquee:

Almost full moon
a luxurious voice
on the answering machine

If you've been to Times Square recently, you'll know that it has changed. In the late 1990s, most of the theaters were purchased by major entertainment companies; their facades were modernized and branded with corporate graphics. Nowadays it feels more like Epcot Center than the Times Square I once knew. Change and transformation are part of what makes Times Square enchanting, so I know I can't complain too much. But as a New Yorker of fifteen years, it's my right to say, "I rememba when. . . ."

Last year, I rediscovered the photo I'd taken of that old marquee, which now no longer exists. In an attempt to render those signs immortal, and as my own subtle protest against modernity and change, I decided to create a typeface based on their letterforms. I called it Marquee.

Studio: *Cubanica*
Art direction: *Pablo A. Medina*
Typeface design: *Pablo A. Medina*
Poster design: *Pablo A. Medina*
Reference photography: *Pablo A. Medina*
Client: *Independent project*
Year: *2001*

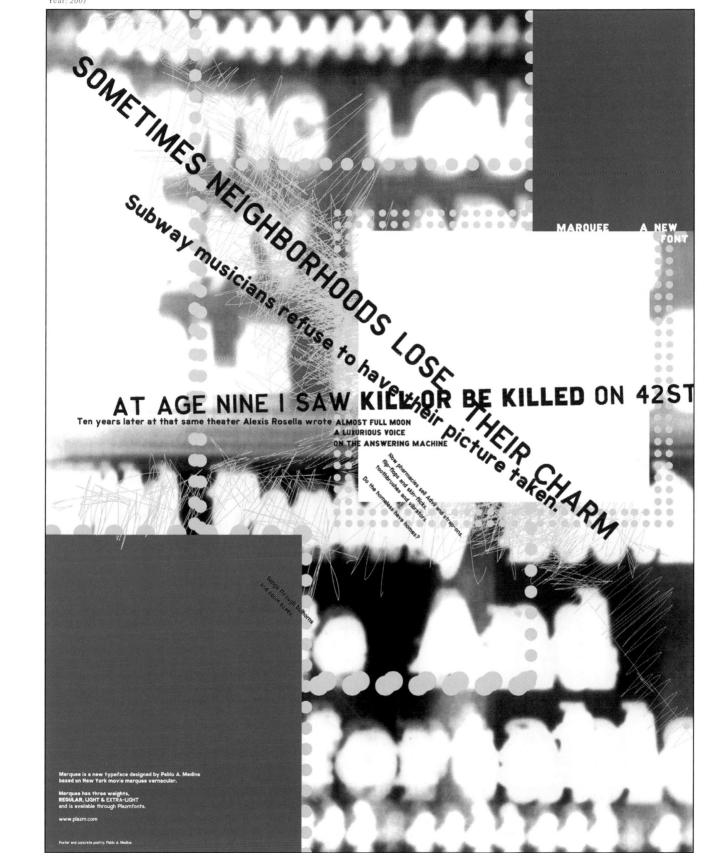

SOMETIMES NEIGHBORHOODS LOSE OR THEIR CHARM

Subway musicians refuse to have their picture taken.

MARQUEE A NEW FONT

AT AGE NINE I SAW KILL OR BE KILLED ON 42ST

Ten years later at that same theater Alexis Rosella wrote ALMOST FULL MOON
A LUXURIOUS VOICE
ON THE ANSWERING MACHINE

Now pharmacies sell Advil and strep-ons,
flip-flops and skin-flicks,
toothbrushes and vibrators.
Do the homeless have homes?

Songs through bullhorns
and boom boxes

Marquee is a new typeface designed by Pablo A. Medina
based on New York movie marquee vernacular.

Marquee has three weights,
REGULAR, LIGHT & EXTRA-LIGHT
and is available through Plazmfonts.

www.plazm.com

Poster and concrete poetry: Pablo A. Medina

Pipes

Garages are known as creative havens that spawn everything from rock bands to computers—but typography? Why not? With his love of everyday objects, John Dorocki, a student in my experimental typography course, found letterforms in the mundanity of plumbing supplies. Here's what John said about his process:

> I found myself in my garage, sifting through an old bucket of plumbing supplies. They just seemed right. They had the perfect weight, shape, and minute detail that I was looking for. I began fitting one piece into another, sometimes more successfully than others.

I tried finding the necessary parts to finish all twenty-six characters. A nice faucet head, which didn't quite make anything except a really big "J," now takes up space in my room. I finally found all of the parts needed except those for the "Q." Fortunately, a girl in my class told me that her dad was a mechanic, and she remembered using some clamps that looked like "Q"s as bracelets when she was young.

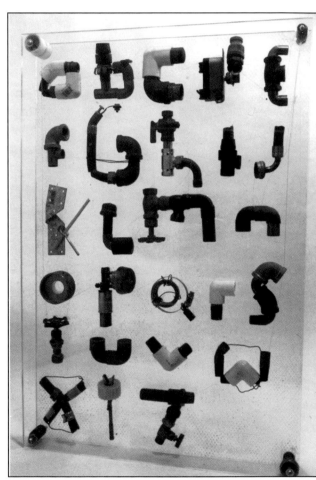

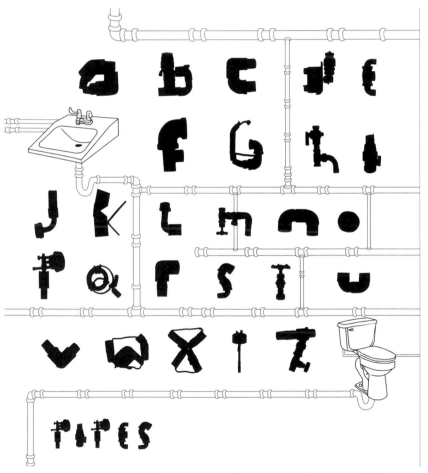

Class: *Experimental Typography,*
Parsons School of Design
Teacher: *Pablo A. Medina*
Letterform design: *John Dorocki*
Photography: *John Dorocki*
Year: *2001*

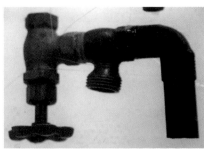

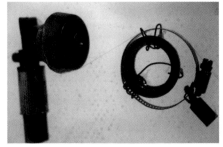

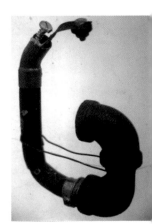

Union Square was created for no other reason than to recognize and recontextualize the beauty of New York City's mosaic subway typography. About four years ago, I noticed the charm of these letterforms and started taking pictures of them in the subway stations, from Astor Place to Borough Hall to Union Square. After the initial inspiration, the biggest challenge was simplifying the forms to function as line art, and creating a consistency so they could translate from small to large display formats.

Studio: *Cubanica*
Art direction: *Pablo A. Medina*
Typeface design: *Pablo A. Medina*
Poster design: *Pablo A. Medina*
Reference photography: *Pablo A. Medina*
Client: *Independent project*
Year: *2002*

TOUPEE

TOUPEE was created by Noel Honig in 1996 as a vehicle for situational pranks, inane art, and general hi-jinx. Founded in the spirit of the low-brow, post-punk lifestyle of New York's East Village, and with the clear objective of creating work that could never be called corporate, Toupee somehow managed to land clients as diverse as the Smithsonian Institution, Levi's, and Polo Jeans.

Noel Honig was born in 1970 and has been making short films and videos ever since. His videos and films have been seen on MTV, as well as at countless film festivals around the world. In 1997, he received a Martin Scorcese Award for his short film *Stop It*, and in 1999 won first prize in the Levi's-sponsored Digital Catapult competition for his short film *Alva*. In 2001, his animated music video for Guided by Voices was voted *CMJ*'s "Pick of the Week" and went on to play at numerous animation festivals, including the Ottawa International Animation Festival. Honig lives in New York City, teaches part-time at Parsons School of Design, and is currently trying to reverse the damage done to his soul by attending New York University's graduate film school six years ago.

"I Drove a Tank" music video

I teach broadcast design at Parsons School of Design in New York City and I'm always trying to come up with new, interesting projects for my students. Because of my music video experience, my students often want to try making one themselves. But I wasn't interested in them making videos with no bearing on the real world. I wanted to give them an experience as close as possible to one that they would have in the workplace. Since I had recently made a music video for Guided by Voices, and know that the band's leader Bob Pollard is incredibly prolific, I contacted his manager, David Newgarden, and asked if my class could make official videos for Bob's then-recent record *Choreographed Man of War*. Bob and David were really into the idea, so they sent us ten CDs (one for each song), and we began.

The two most challenging aspects of the job were that Bob didn't have time to schedule ten music videos shoots, and the tiny indie label (Luna Records) didn't have any budget for us. But we always have to turn adversity into advantage. So I decided that the videos would be made up of whatever materials my students could beg, borrow, or steal—found object videos, in other words.

We drew straws to see who got what video. I had already decided that I wanted to do one of the videos myself—because I love Bob Pollard's music, and also so that my students could watch mine alongside theirs. I was randomly assigned the first track on the album, "I Drove a Tank."

The overall concept of my video for "I Drove a Tank" was defined in large part by the terrible events of September 11. I live and work in downtown Manhattan, and I was just as shocked and scared as everyone else was by the attacks. Since I was just beginning to conceptualize the video at that point, it all fell into place easily and quickly. "I Drove a Tank" is a song that references militarism and has an overall tone of odd dreaminess and surrealism. I wanted to make a video that showed our collective fear of war and its horrors but without pointing to any specific threat—more like a dream about a terrible war against a faceless enemy.

I liked the song's imagery of a man driving a tank, because even though a tank is a tremendous weapon, it is also a giant protective shell containing a person. It is simultaneously an offense and a defense, if you will, and I wanted to play with that metaphor.

At the time I was watching the news constantly, and I began to reshoot images off of my television onto digital video: Specifically, I looked for explosions, soldiers, anyone riding a tank, or any army footage shot with a night-vision camera. I pared all of that footage down to the best stuff, and brought it into my computer. Using Final Cut Pro, After Effects, and Illustrator software, I broke the best shots down into single frame sequences, then altered frames individually to create new footage based on the found footage. Mostly I ran these frames through Illustrator and applied filters to soften the images and create a more painterly look. I did this in Illustrator because I'm sure that nobody else ever uses it for this purpose—and now I understand why. The software isn't made to do it, and on top of that it's a painfully slow process. But you can still get some interesting new looks.

To show the fear of war, I broke out my collection of airplane security cards. I scanned in images from these cards that showed people in danger situations—crouching with their heads down in crash positions, reaching for or breathing through oxygen masks, and so on. These images had a heightened, new meaning in light of the attacks on the World Trade Center (WTC) and the Pentagon.

In the days after the attacks, I walked around "Ground Zero" and collected any printed materials that I could find from the WTC debris: burned pieces of newspaper, half a page of someone's tax return, a charred registered mail receipt. When I began creating imagery for the video, I used these materials and others to create collages, which I distressed in a variety of ways: by rubbing ink on them, cutting out strips of black tape and applying them on top, burning them with a lighter. I also included a few newspaper cutouts of imagery from September 11, such as the WTC in flames. I made sure that none of the imagery was too distinct; I didn't want to be

Like many of the images from my music video, this one was created using an accidental or automatic process. First I scanned some images from airline safety cards, cropped them, changed the colors, applied a few effects on top of that, and animated them into a jittery, randomly sequenced dance. Then I found some old military footage and reshot it from my television using a digital camera. I broke that video footage down, frame by frame, into individual PICT files, then brought them into Illustrator, where I treated each frame with a different effect. That sequence of Illustrator files then became another layer in the final video design mix. Since each frame of each layer was unique, when I stuck the layers together in a random way I discovered many happy accidents—such as this image of a paratrooper about to jump out of a plane while a ghostly woman in the sky breathes into an oxygen mask and watches.

One of the first frames of the video, a magazine image with handmade painted elements

Another result of an automatic design process. The found objects are a detail from an airline safety card and an image of an explosion, which I shot off my television and then animated using a series of After Effects plug-ins. I combined the two layers in After Effects. When viewed together, the explosion seems to happen right in the woman's chest. This placement was pure chance.

Hand-drawn and painted elements. The veiny treatment was done with an After Effects plug-in called Vector Paint.

One of the shots in the music video is a collage of airline safety card characters (all in distress positions) layered on top of each other. I was hoping that the sequence would provoke the feeling of a plane crash. In this particular still, I love that the child's head happened to fall right into the abdomen of the pregnant woman. It could be titled "Family Plane Crash."

A magazine composite being deformed, with some handmade elements

obvious. When I cut up the photo of the WTC on fire, for instance, I reduced the image to show only a small piece of the building's stripy exoskeleton.

The other design concept of the video was using images of pornography. I decided to incorporate porn for a variety of reasons. It provokes a strong reaction in people. The images address lust and power, and in some sense domination—all of which are emotions applicable to war. In

contrast to the men in the video, who are all soldiers, I wanted to show women as victims of war. Rape has often been used as a tactic of war, both in the past and the relative present, and the pornographic imagery invoked that for me.

This sense of women as victims of war ran through the video in a number of ways other than in the porn imagery. When I selected different shots from the airplane security cards, I used almost exclusively images

Magazine composite with hand-drawn elements

Another image that blends a go-go dancer (left, pink), an airplane passenger in distress, and blurry textures from my collage of newspaper clippings and WTC paper debris (you can see this layer most clearly inside the oxygen bag). I selected this frame because I love the visual flow and colors.

Magazine composite with hand-drawn elements, now with color washes splashing over, and typographic elements that I created in Illustrator and animated in After Effects

In the narrative of the music video, a pink army fights a green army. This shot depicts a large, pink, three-dimensional structure tumbling downward in a pile of twisted wreckage. It goes without saying that the terrible sight of the WTC falling inspired this image. Behind that, a woman from an airline safety card awaits a crash, all alone. This frame suggests terrible anxiety and destruction to me.

Hand drawings combined with animated/film-stripped pictures and artwork

One of my simple illustrations of a pink tank. In the background you can see a detail from one of my collages. The stripy texture on the lower left-hand side of the frame is a photo of the WTC's exoskeleton, blended into the collage along with dark ink-stains and layers of transparent tape.

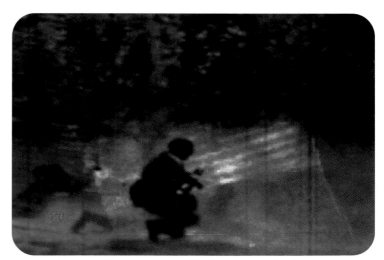

Typographic elements combined with magazine images

This is some of the military footage that I reshot digitally from my television, combined with a photo of the WTC's stripy exoskeleton (diagonal, around the soldier) from my collage. I added fake film scratches onto the military footage to give it an older, timeless quality.

of women in distress. I also obtained some shots of 1960s go-go dancers who were flailing around and appeared as if hysterical, and turned these into simple, tinted animation sequences. Removed from their original context, these also provoke a feeling of distress.

I took all of these pieces of found footage and images, blended them together with a number of simple line animations that I drew depicting a pink army fighting a green army, and set it all in time with the music. I wound up with a music video that I liked a lot, and that was selected for inclusion in Amina Mundi, South America's largest animation film festival.

Studio: *Toupee*
Art direction/Design/Illustration: *Noel Honig*
Client: *Luna Records*
Year: *2001–2002*

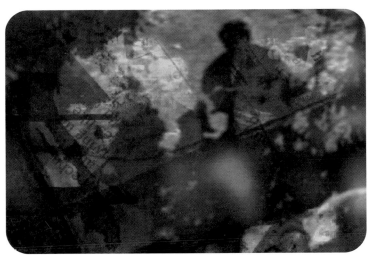

Typographic elements combined with a magazine composite, drawn over with relative text

Here you can see clearly how the reshot military footage combines visually with the collage layer of torn, burned pieces of WTC debris. I believe that the white piece of paper in the top center of the frame is a fragment of a burned tax return found at the site.

Magazine composite with hand-drawn elements

This image comes toward the end of the video, when the pornographic imagery becomes more explicit. The paratrooper in the center appears poised to leap into the woman's ass. Blended on top of the porn image is a frame from a scratchy, hand-drawn animation layer that I created.

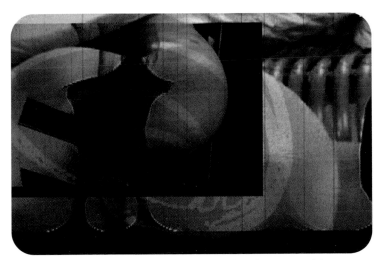

Magazine composite being deformed and interrupted by graphic elements

A frame or two later, and the paratrooper (indistinct in the center) leaps from the plane. Here I was using a base layer of two porn frames blended together so that their flesh tones would combine where they overlapped. I love the way the innocent wood of the couch behind the woman seems to become menacing talons or grasping fingers. And again, a frame from my scribble animation layer is overlaid on top of the other imagery.

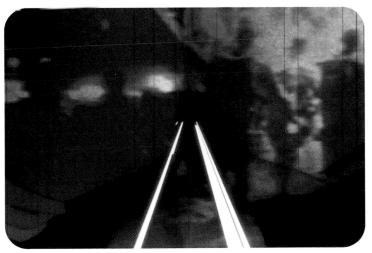

Composite with hand-drawn and vector-painted elements

This is defense department footage, reshot off of my television and combined with pornography. At the bottom of the frame you can see the word "Strike" in red, layered over the person's upside down face. I believe this came from CNN's headline phrase "America Strikes Back."

BRIAN ROETTINGER was born in 1977. Twenty-two years later he began designing album covers for the independent punk label Hopscotch Records. He is a founding member of SuperRage, a collective of graphic designers that organizes public visual interventions on social, political, and economic issues. He collaborated on the Center for the Study of Political Graphics' "Globalize This" benefit party, which included a series of honoree posters, one for the renowned masked provocateurs, the Guerrilla Girls.

Roettinger continues to explore the possibilities of music packaging while art directing and designing for such independent labels as Dim Mak; Sound Virus; and his own D.I.Y. label, Hand Held Heart. In addition, he has designed for a number of bands, including the Blood Brothers, Liars, and This Machine Kills. He lives on the edge of civilization outside Los Angeles and studies graphic design at California Institute of the Arts.

Sissy Spacek 7-inch album cover

The soundtrack to the student film *Das Neu Monster* was the musical source and inspiration for this avant-noise record. The 7-inch cover was screen-printed over the film's promotional poster.

Elements from photocopied frames of the film were manipulated by hand and gathered with miscellaneous photo-copies from the Kinko's recycling bin. These were then composed by hand, scanned, and prepared for silk-screening.

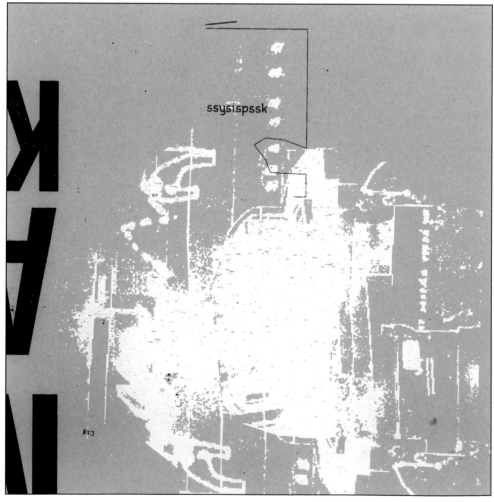

Design: *Brian Roettinger and John Wiese*
Client: *Hand Held Heart*
Year: *2001*

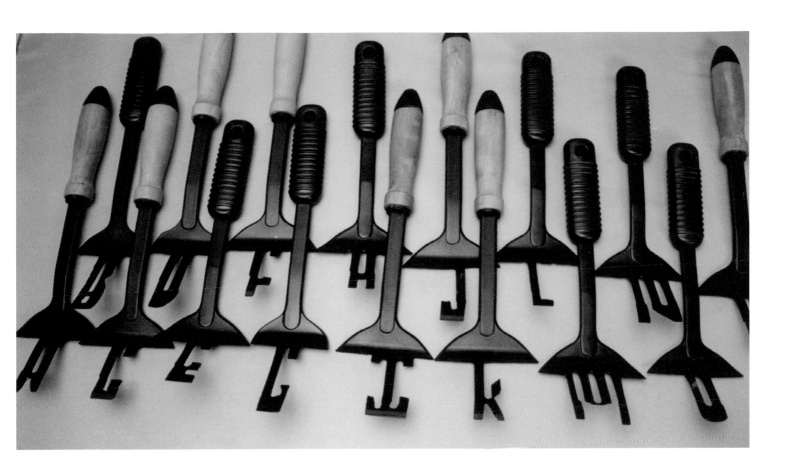

Melldone typeface poster

This piece was made as a typographic experiment. I bought twenty-six spatulas at two for 99 cents. Each character was created with specific detail based on the form of the spatula (excluding the handle).

The form of each character was cut from the spatula on a band saw. Material was only removed and not added to the spatula to create the character. Many restrictions were taken to keep the characters similar, but since two different brands/styles of spatulas were used, you will notice minute variations between them.

Art direction: *Brian Roettinger*
Typeface Design: *Brian Roettinger*
Poster Design: *Brian Roettinger*
Photography: *Brian Roettinger*
Client: *Independent project*
Year: *2001*

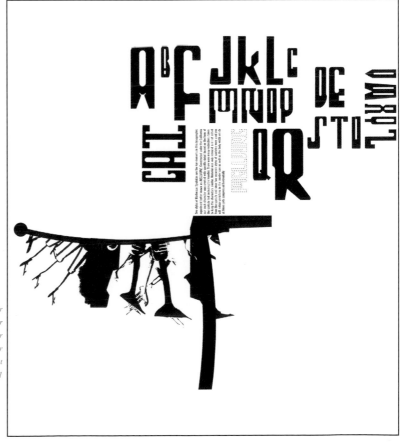

Studio 2 poster

This was the end-of-the-year Studio 2 poster for design students at California Institute of the Arts. Most of the elements contained here are doodles found in sketchbooks and on the walls and bathroom stalls in and around the studio. Some were inside jokes, others refer to work done within the studio. Each element was digitally photographed and prepared for silk-screening.

Art direction: *Brian Roettinger*
Design: *Brian Roettinger and Sam Furtsing*
Client: *California Institute of the Arts*
Year: *2002*

Super 8 Memories

I have an obsession with the connotations, denotations, and novelty of the Super 8 camera. My childhood memories are stored in boxes of washed-out Super 8 films and crusty old photos. These films and photos were the basis for a series of formal technique experiments in which the found objects had a special connection to my childhood.

For this project, I studied each object at various angles and then drew it from memory. I did the same with elements picked out from 1970s family photos found in a local thrift store. I used old markers, dull pencils, and dead pens, just as I would have done as a kid.

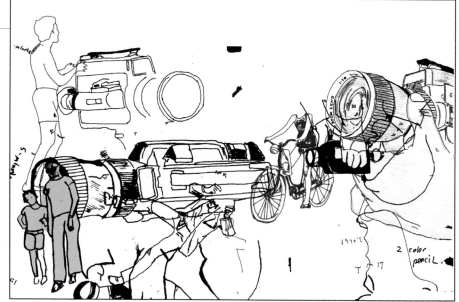

Art direction/Design: *Brian Roettinger*
Client: *Independent project*
Year: *2002*

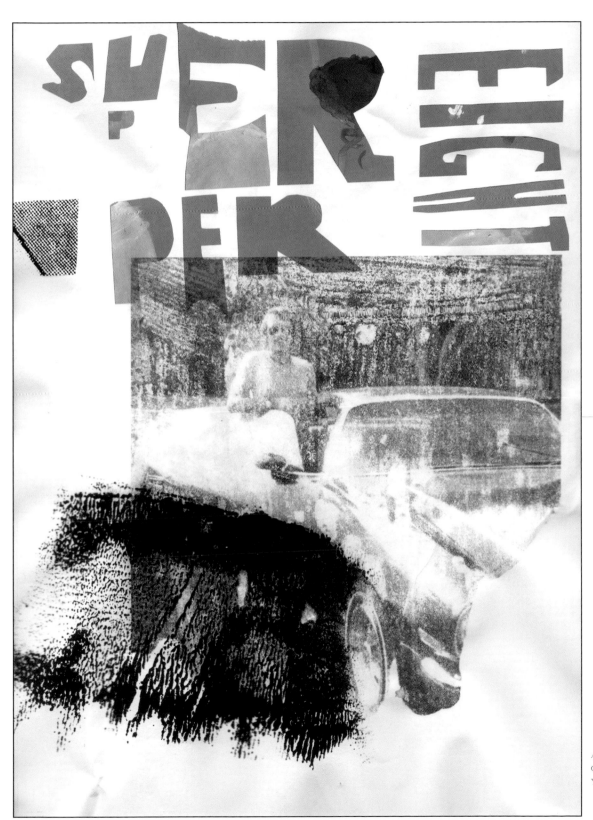

Super 8 poster

This poster was part of a series based on the Super 8 camera (see also *Super 8 Memories*, opposite). A photo album found in a local thrift store was transferred to paper with nail polish remover and a fork. A broken Super 8 camera was then inked up and pressed to the paper. The type was made with found paper scraps from a nonprofit arts organization in Los Angeles.

Art direction/Design: *Brian Roettinger*
Client: *Independent project*
Year: *2002*

stephenDOYLE

STEPHEN DOYLE is the principal and art director of Doyle Partners, a New York–based design studio founded in 1985. Doyle Partners has established a reputation for creating programs implemented with discipline and imagination. Clients include the Cooper-Hewitt National Design Museum, Barnes and Noble, Talk Miramax, Metropolitan Transport Authority, the Museum of Modern Art, Virgin Records, and Knopf.

Stephen Doyle often hybridizes design and artwork, merging the public and private. His constructions have been published by *The New York Times*, and his critiques by *Creative Review* in London. *ID* magazine reported that Doyle "rejects fashionable styles in favor of solid, functional approaches rooted in concept, not adornment . . . all without losing his sense of humor."

Studio: *Doyle Partners*
Art direction/Design: *Stephen Doyle*
Photography: *Victor Schrager*
Client: *Los Angeles AIGA*
Year: *1995*

Previously, Doyle was art director of M&Co., and associate art director at *Rolling Stone* and *Esquire*. He is a member of AIGA and the Society of Publication Designers, and in 1995 was elected to the Alliance Graphique Internationale. In 1999, he was awarded the prestigious St. Gaudens Award from his alma mater, the Cooper Union. Doyle lectures in the United States and abroad, exposing the inspiration for his work. He has taught at Yale, the School of Visual Arts (New York), the Cooper Union (New York), and New York University. In 2000 he joined the Cooper Union board of trustees.

If A then B

If A then B is about the inextricable linking of cause and effect, a Siamese twin of an idea. When I was a kid, my parents had a set of two Shakespeare books that shared one slipcase. The spines were labeled with right-reading type, but the words were broken in two, for fit. So, as a child, I thought the books were "Come Dies" and "Trage Dies," and I wondered who would read two whole books about these people—"Come" and "Trage"–dying, and what could be so interesting about that. Eventually, I learned that the set was more balanced, comedies being offset by tragedies. Ever since then I've been intrigued by the pairing of two books.

The piece had the advantage of being a sculpture I made before turning it into a poster. It originated with a conversation I had with Chip Kidd. I was complaining that my graduate students at Yale seemed to be lacking any sense of irony, and he quipped, "If A, then B." This idea of cause and effect sparked my sense of irony, and I bolted this painted and labeled pair of books together to illustrate the equation. Later, I turned the sculpture into a poster for a talk I was presenting to the Los Angeles AIGA with my former partner, Bill Drenttel. The two books bolted together suggested our partnership: two completely different minds working in tandem. But of course, that is the post-invention rational spin that we designers layer onto the things we make intuitively.

I find the books that I use in my sculptures in the many secondhand bookstores in New York City, though I'm loathe to name the shops for fear they won't sell me any more books once they find out what I do with them.

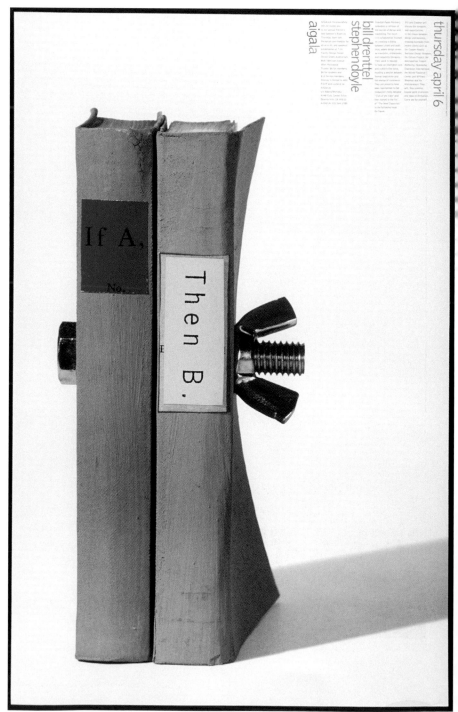

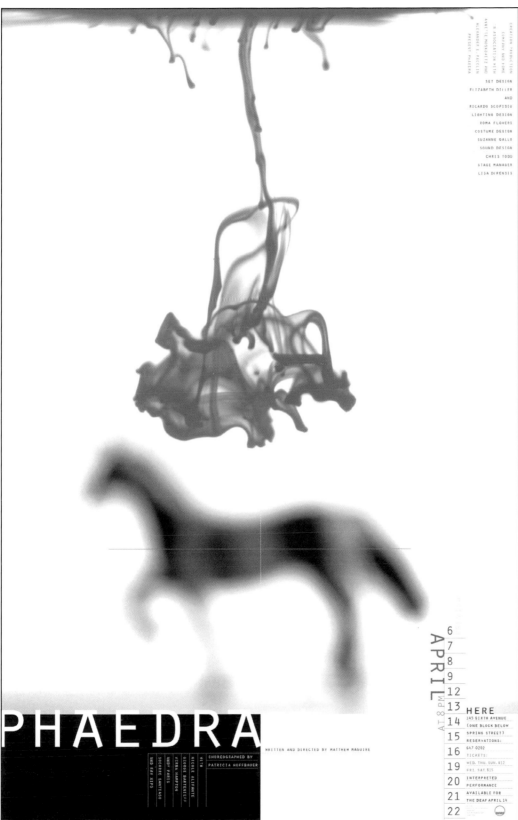

CREATION PRODUCTION
COMPANY AND HOME
IN ASSOCIATION WITH
ANNETTE MOSKOWITZ AND
ALEXANDER E. RACOLIN
PRESENT PHAEDRA

SET DESIGN
ELIZABETH DILLER
AND
RICARDO SCOFIDIO
LIGHTING DESIGN
ROMA FLOWERS
COSTUME DESIGN
SUZANNE GALLO
SOUND DESIGN
CHRIS TODD
STAGE MANAGER
LISA DIFRENSIS

PHAEDRA

WRITTEN AND DIRECTED BY MATTHEW MAGUIRE

CHOREOGRAPHED BY
PATRICIA HOFFBAUER

WITH
NICOLE ALIFANTE
GEORGE BARTENIEFF
VERNA HAMPTON
ANDY PARIS
SOCORRO SANTIAGO
AND DAV XIFO

APRIL 8 PM

6
7
8
9
12
13
14
15
16
19
20
21
22

HERE
145 SIXTH AVENUE
(ONE BLOCK BELOW
SPRING STREET)
RESERVATIONS:
647-0202
TICKETS:
WED. THU. SUN. $12
FRI. SAT. $15
INTERPRETED
PERFORMANCE
AVAILABLE FOR
THE DEAF APRIL 14

Phaedra

This poster was intended to advertise *Phaedra*, a drama about incest, bestiality, and the revenge of Venus, the goddess of love. The client was the author of the play, my friend Matthew McGuire. We wanted to project a sense of threatening intensity with drama and precision.

The found object in the poster is my daughter's little plastic horse, shot out of focus. Once we were assigned this poster, I knew that we needed a horse but didn't want specificity; blurring solved the problem. You can't exactly tell it's a toy, even though it's in a rather clichèd position; it's a caricature—the *idea* of "horse" rather than a horse itself. The blood was shot in sharp focus to heighten the drama of its shape dissolving into the water.

This is what Maguire had to say about the poster: "This threatening liquid seems to transform from blood into smoke. The horse, into which Hippolytus displaces his suppressed sexuality, seems to vanish, but is arrested in the crosshairs: the crosshairs of Phaedra. The elements of a Greek tragedy—blood, metamorphosis, animal passion, and fixation—are present in a way that contemporizes the myth, fragmented and recombined, uneasily bound as if it might implode. Thanks, I owe you big."

Studio: *Doyle Partners*
Art direction/Design: *Stephen Doyle*
Photography: *Stephen Doyle*
Client: *Creation Production*
Year: *1994*

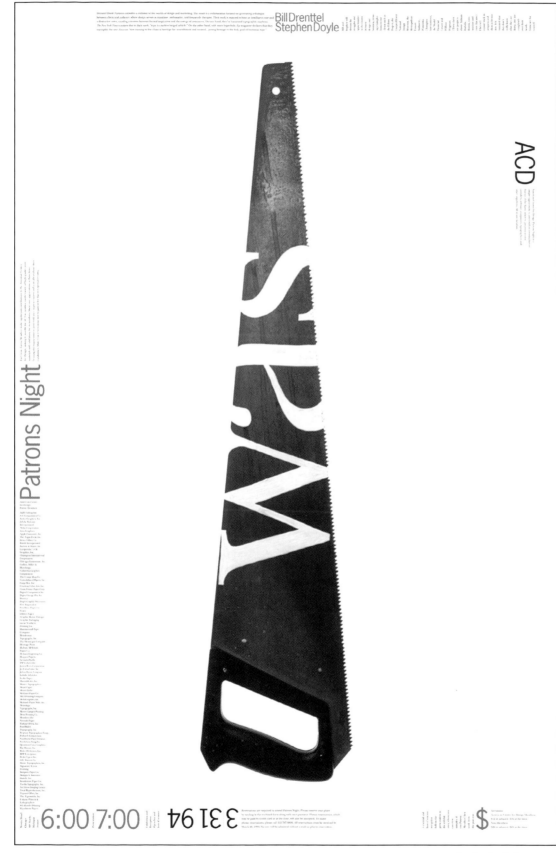

Was/Saw

Was/Saw is a kind of symbol/sign riddle that had its genesis in my dad's psychology books. "Was" and "saw" are classic examples of dyslexia, and I wondered if the flip-flop would stand up to word and object. I later spotted this saw at a construction site; because it was all rusty, it occurred to me that it really wasn't a saw anymore—it *was* a saw, but no longer. The old dyslexia paradigm occurred to me, and I knew that I had to combine this object with its antithetical word.

The design was first made as a piece of art, but then months later I was able to use it to announce a speech at the American Center for Design given by myself and my old partner, Bill Drenttel. It was appropriate, I thought, because of the back-and-forth nature of the saw, the back-and-forth nature of the word, and the back-and-forth dialogue between the two of us in the talk.

Studio: *Doyle Partners*
Art direction/Design: *Stephen Doyle*
Photography: *Victor Schrager*
Client: *American Center for Design, Chicago*
Year: *1994*

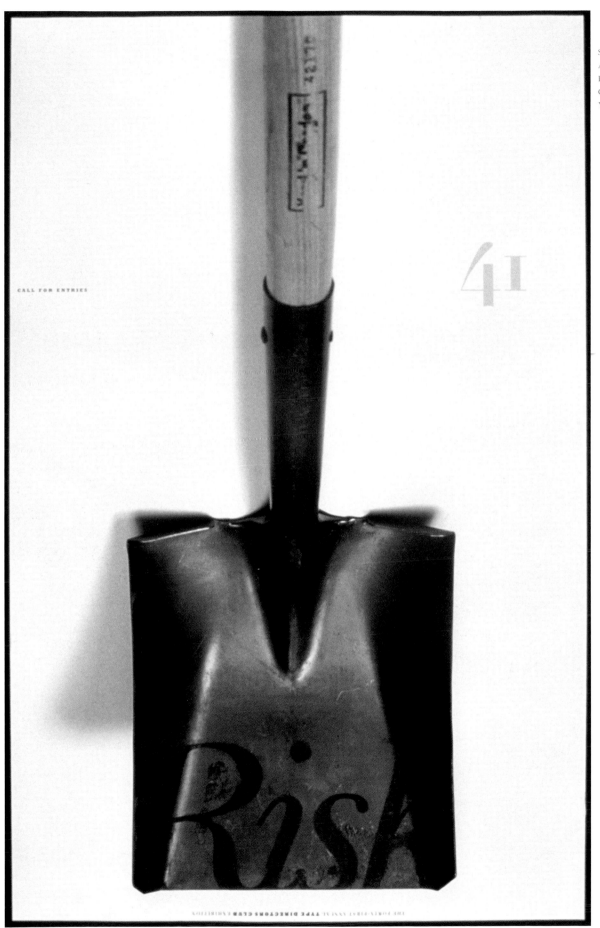

CALL FOR ENTRIES

Studio: *Doyle Partners*
Art direction/Design: *Stephen Doyle*
Photography: *Victor Schrager*
Client: *Type Directors Club*
Year: *1995*

Risk

This poster was used as a call for show entries for the Type Directors Club, and has multiple interpretations. A simple one is that you should dig through your stuff to discover which pieces have an element of "risk," and then submit those pieces to the show. Another is that risky behavior will dig your grave. A third is the dichotomy of the word/command "risk" as applied to a tool connected to manual labor and covered with rust, suggesting the endeavor and labor of "risk," and the time it takes to accomplish something that has risk. But does this poster work or not? I'm never sure. For me, the design itself was a risk. I found the shovel, scratched the lacquer off of its business end, and applied salt water to it several times a day for ten days to speed up the rusting process.

Neal Ashby is the principal of ASHBY DESIGN, a design studio whose clients include Warner Bros. Records, Virgin Entertainment Group, Rounder Records, ESL Records, EMI Music Group, and National Geographic.

For ten years, Neal Ashby was vice president and creative director for the Recording Industry Association of America. His work has been published by *Print, HOW, ID, Graphis*, and *CA* magazines, and he has won awards from the New York Art Directors Club, AIGA, the Type Directors Club, the American Center for Design, and the Designers and Art Directors Association of the United Kingdom (D&AD). He is also an adjunct faculty member of the Corcoran College of Art and Design in Washington, D.C.

Tongue Brushings
CD packaging

There are clients with high budgets and clients with low budgets. And then there are clients with no budgets. Emerging folk/grunge artist Dave Starr didn't have much of a budget, but he did have a great collection of songs, called *Tongue Brushings*, which he wanted to market to A&R people in the recording industry. We agreed on the concept: To ironically refer to "tongue brushing," we would show the tongue of a shoe, preferably an early-era Keds tennis shoe. Not having the money for either a pair of vintage shoes or photography, I set out to find a photo of the perfect tennis shoe. At an antiques store in Richmond, Virginia, I found a Sears circular from 1964. The Keds shoe we needed appeared on the last page, advertised for $2.97 a pair.

After scanning the image of the shoe, I used the blurring tool to subtly eliminate any halftone screen from the original printing. I converted the image to CMYK, then manipulated the curves to create a sepia-toned version of the shoe, giving it a more vintage feel.

Studio: *Ashby Design*
Art direction/Design: *Neal Ashby*
Client: *Dave Starr*
Year: *1998*

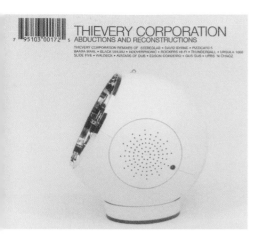

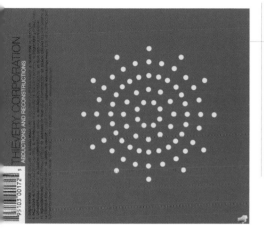

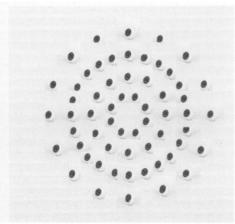

Abductions and Reconstructions
CD packaging

Eric Hilton and Rob Garza (aka Thievery Corporation) came to me after seeing an annual report I had designed for the Recording Industry Association of America featuring retro objects. They wanted to use a photo from the report, of an obscure orb eight-track player from 1970. I struck a deal with them: I'd let them use the photo, but only if I could design the whole package. Even though they wanted a strong hand in the design (they art direct all of their products closely), they were open to working together.

To reference the title of the CD, *Abductions and Reconstructions*, we took a smaller photo of the orb and reconstructed it to re-create the speaker grille holes on the side of the player. We also took the speaker grille pattern and used it as a logo for the CD plate, t-shirts, and in-store marketing tools.

Studio: *Ashby Design*
Art direction/Design: *Neal Ashby*
Client: *Thievery Corporation*
Year: *2000*

I collect antique frames, so I'm always buying old photographs and paintings and then taking them apart to salvage the frames. Once, I found an interesting illustration from a children's book stuck behind a 1940s photograph; the illustration was of a boy serenading other children with his violin on a mountaintop. The picture was fascinating to me: children presented with melancholy in such an innocent way. I put it in a folder I keep of found images and would refer back to it every so often. About a year later, a friend of mine challenged me to design something without a client, as a way of art therapy. I combined the children's illustration with a picture from the back of a period View-Master box to come up with a series of posters I wanted to silk-screen for myself.

I never did get around to making the posters, but I did create business cards, printed altogether, inviting the viewer to choose their favorite. To make the illustration work better with the bright colors of my design, I saturated the primary colors of the illustration in Photoshop. I turned the sweater of the boy into a lime green, and made the sky a bright, deep blue.

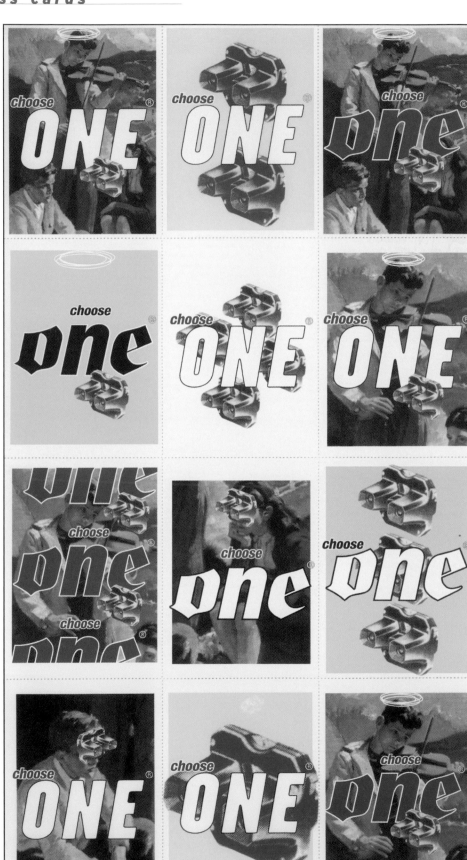

Studio: *Ashby Design*
Art direction/Design: *Neal Ashby*
Client: *Independent Project*
Year: *1996*

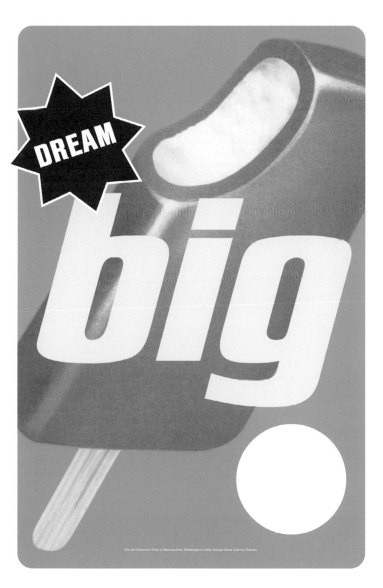

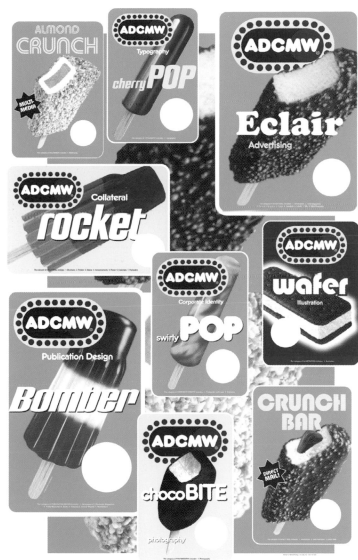

Studio: *Ashby Design*
Art direction/Design: *Neal Ashby*
Client: *The Art Directors Club of Metropolitan Washington*
Year: *1996*

Dream Big: announcement for the Art Directors Club of Metropolitan Washington

Maybe it's the eight-year-old in me, but I've always been drawn to the touristy popsicle vans parked at the mall in Washington, D.C. I love the way the popsicles are advertised: a haphazard collage of colorful stickers covering every open inch of space. I didn't know if I would ever actually be able to use them, but I wanted a collection of those stickers. In broken Korean-English, a vendor told me where to get the stickers: at the distribution center where they pick up the food, candy, and sodas. When I got there, I found the stickers, loose and scrambled in a big box. I felt like a kid in a candy shop—but then, I *was* a kid in a candy shop. A month later, when the Art Directors Club of Metropolitan Washington gave me creative reign on designing the invitation to its fiftieth annual show, I had my opening to use the collection.

Because most of the popsicles on the original stickers were obscured with type, I had to redraw large portions of them using the cloning tool in Photoshop. Once this was done, I put my own type on top.

slowHEARTHstudio

Founded by Sean Mosher-Smith, a former senior art director of RCA Records, and his wife, Katie, in 1992 in Brooklyn, New York, SLOW HEARTH STUDIO is a design firm with an extensive portfolio of work in graphic design, photography, photo-illustration, and typography. The studio has created everything from Web sites and CD packaging to book covers and editorial photography, often blending design, typography, and photography to produce rich, textural images and designs that range from provocative portraits to dream-like scenes and eerie landscapes. Clients have included *Time* magazine, *The Village Voice*, RCA Records, Viacom, Avon Books, MTV, Universal Records, and Warner Bros. Slow Hearth's work has been featured in *Communication Arts*, *IDEA*, *IdN*, and *Photo District News* magazines; *Cool Type 2wo* (North Light Books, 1999); and the Art Directors Club of New York's Young Guns exhibit.

Face: the Future (series)

This series, a study of type design, uses discarded pieces from faxes, color bars, and found type. We collected type samples from labels, posters, neon signs, and discarded test photos from previous photo shoots, and then collaged them digitally. Made originally for self-promotional use, the series was later used as the cover design for an as-yet-unpublished book on typography, which was later scrapped.

Studio: *Slow Hearth Studio*
Art direction: *Spencer Drate*
Design: *Sean Mosher-Smith*
Client: *Independent project*
Year: *2001*

DV (series)

These pieces in the Digital Vision (DV) series were used as studio promotions after being rejected by DV (the original client). The pieces combine various found objects, including labels, packaging, underexposed photos, faxes, envelopes, and food. Each piece was created by pulling from an enormous file of elements collected over a period of three years.

Studio: *Slow Hearth Studio*
Art direction/Design: *Sean Mosher-Smith*
Client: *Digital Vision/Independent project*
Year: *2001*

Spin Doctors: Dodging Assassins CD packaging

The background artwork for this CD package was comprised entirely of found images: coffee rings, found paper, thumbprints, newspaper, cigarette butts, and so on. We wanted it to look like a discarded police blotter. Objects were collected off the streets of Brooklyn, combined with line-up photography of the band, and then thrown together digitally.

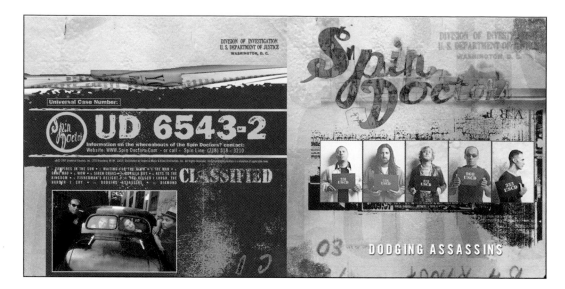

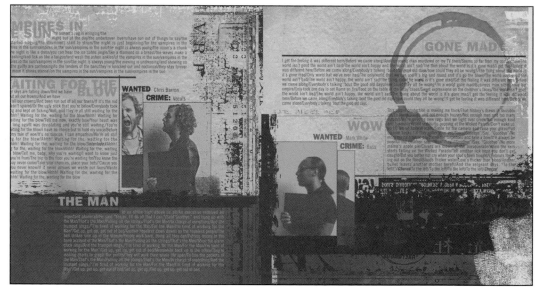

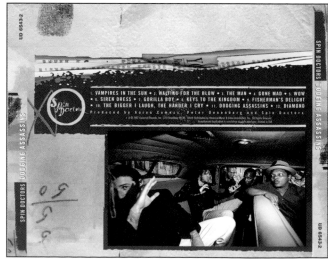

Studio: *Slow Hearth Studio*
Art direction/Design: *Sean Mosher-Smith*
Client: *Spin Doctors*
Year: *1999*

RE:LAUNCH

We tried to keep this poster announcing the relaunch of the Slow Hearth Studio Web site as minimalist as possible. The idea was to announce something that lived digitally, but to do it in an organic way. Elements used include a laundry list from the 1800s (bought at a tag sale), a fax cover sheet that had come through badly, old file folders, ripped paper that was found outside, and some Morse code. The objects, chosen for their simplicity, were collected and scanned together.

Studio: *Slow Hearth Studio*
Art direction/Design: *Sean Mosher-Smith*
Client: *Independent project*
Year: *2002*

1 718-369-1089 1

RE:LAUNCH//.02

The R distribution contains functionality for a large number of statistical procedures. Among these are: linear and generalized linear models, nonlinear regression models, time series analysis, classical parametric and nonparametric tests, clustering and smoothing. There is also a large set of functions which provide a flexible graphical environment for creating various kinds of data presentations.

http://home.nyc.rr.com/slowhearth/

smayVISION

SMAY VISION was founded by Stan Stanski and Phil Yarnall who, after meeting in college, studying in Rome, forming several bands, and eventually moving to New York City, quickly grew tired of working for others. In addition to creating packaging for artists ranging from Jimi Hendrix, Janis Joplin, and the Velvet Underground to Connie Francis, the Meat Puppets, and Megadeth, Smay Vision has created unique designs for clients such as the New York Underground Film Festival, the Rock'n'Roll Hall of Fame, and Barnes and Noble. The studio's work has been recognized in several publications, including *Print*, *HOW*, *Communication Arts*, and *International Designers Network*.

The Best of James Gang CD cover

We always carry cameras with us and photograph pretty much anything in our paths; New York City offers a constantly weird menu of objects. We archive these photographs and they become our "stock photography." The wood background used here, for example, was taken from this archive. The other images and type were taken from old newspaper advertisements. All work was done in Photoshop.

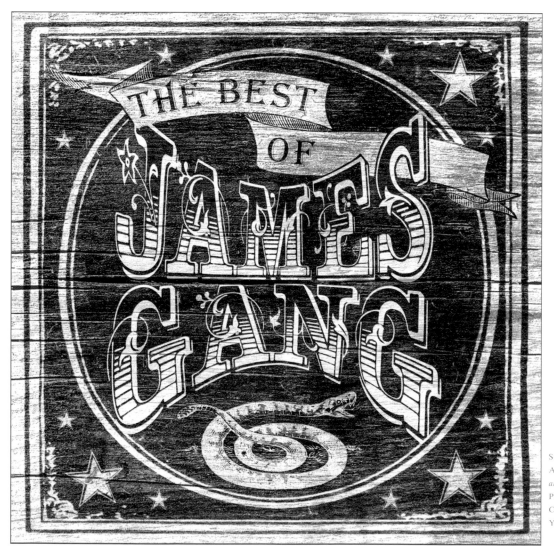

Studio: *Smay Vision*
Art direction/Design: *Stan Stanski and Phil Yarnall*
Photography: *Stan Stanski*
Client: *MCA Records*
Year: *2000*

Splendid Blend CD cover

The Internet music company MusicBlitz.com wanted this cover to show their catalog's diverse and weird selection of music. Type and images were taken from Spanish-language comic books, which were scanned and pieced together in Photoshop.

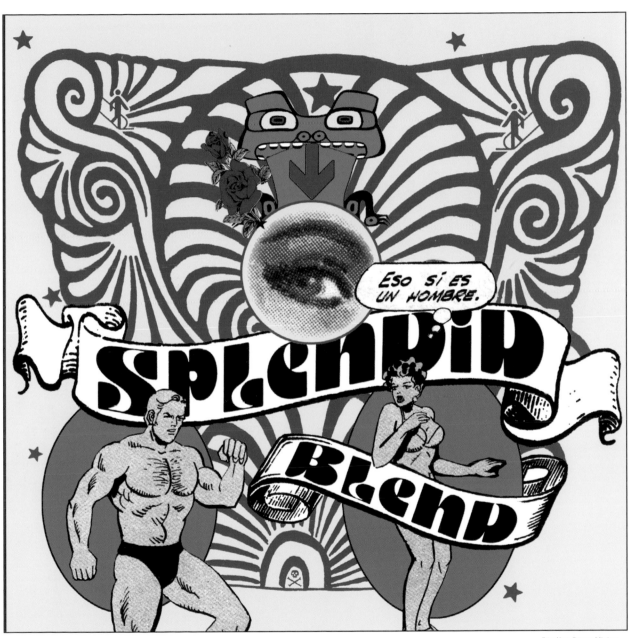

Studio: *Smay Vision*
Art direction/Design: *Stan Stanski and Phil Yarnall*
Client: *MusicBlitz.com*
Year: *2000*

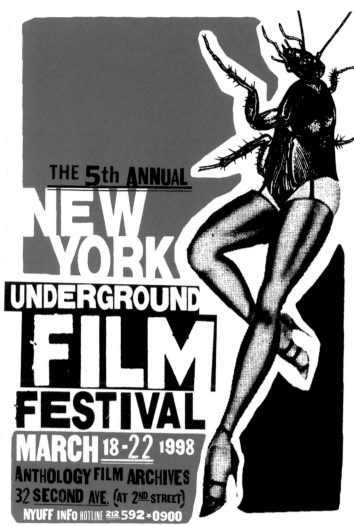

We do the New York Underground Film Festival poster and program every year; this was the first poster we did for them. We opted to combine the old sleaziness of New York with the omnipresent cockroach, a classic urban icon. Using a random roach image and a set of legs from an old Frederick's of Hollywood lingerie ad, we created "Roach Girl." The rest was filled in with old R&B poster type. We scanned the images, converted them to line art, used a little Photoshop here and there, and threw everything together in Quark.

Studio: *Smay Vision*
Art direction/Design: *Stan Stanski and Phil Yarnall*
Client: *New York Underground Film Festival*
Year: *1998*

5th Annual New York Underground Film Festival *program*

This program was the second part of the 1998 New York Underground Film Festival identity, along with the poster (above). In our original brainstorming, we had come up with both Roach Girl (used in the poster) and a sex doll idea, which we also liked and decided to use. We went to Times Square and purchased "Aspen," a lovely young inflatable lass whom we scanned and made famous. We used Photoshop and Quark—nothing fancy.

Studio: *Smay Vision*
Art direction/Design: *Stan Stanski and Phil Yarnall*
Client: *New York Underground Film Festival*
Year: *1998*

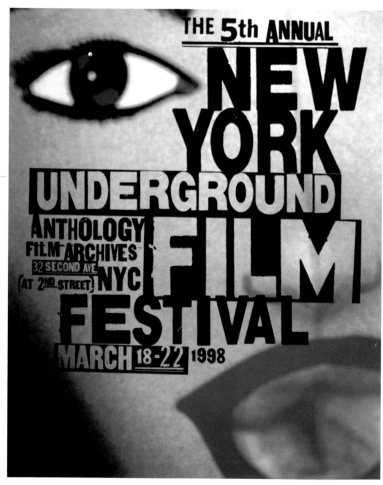

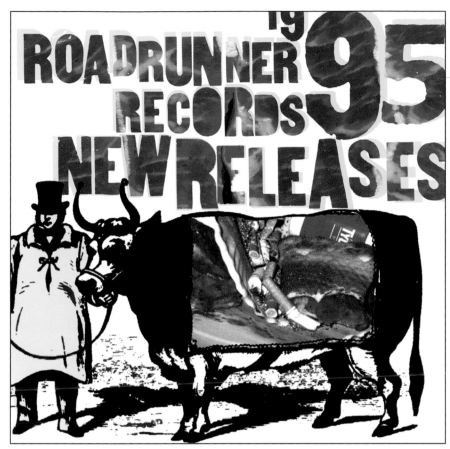

Roadrunner Records New Releases 1995 CD cover

We wanted to show the "heaviness" of this group's music, and thought raw red meat (plus Tylenol and cigarette buts) would work best. We created the type out of actual meat from the supermarket, placing it directly onto our scanner. We then added a photograph of what remained on our table after a party.

Studio: *Smay Vision*
Art direction/Design: *Stan Stanski and Phil Yarnall*
Photography. *Phil Yarnall*
Client: *Roadrunner Records*
Year: *1995*

Smay Vision hot dog promo card

When we do self-promotion, we like to create designs with some intrigue for the viewer. Sometimes we don't even mention what it is that we do, hoping to inspire some potential client to pick up the phone and ask.

Working in New York City, you are not only invaded by the sights, but also the smells. This might have influenced us a bit when designing the promotional card shown here. We bought a hot dog on the street, took one bite, then placed the rest of it on a scanner. The image of the guy is from an old dry cleaner's sign found in New York's East Village.

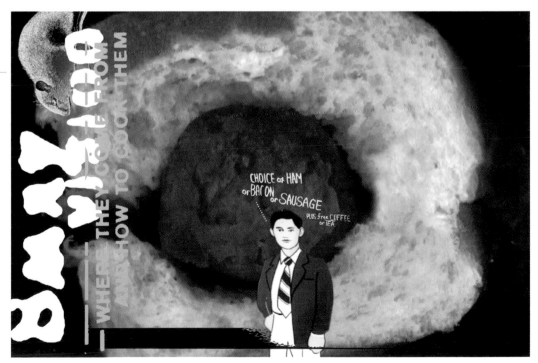

Studio: *Smay Vision*
Art direction/Design: *Stan Stanski and Phil Yarnall*
Client: *Smay Vision*
Year: *1999*

spurDESIGN

Founded in Baltimore in 1995, SPUR DESIGN is a multidisciplinary firm that provides unique design solutions for nonprofit organizations, institutions, publishers, and corporations. Specializing in printed corporate communications, Spur also provides Web development, advertising design, and marketing and branding solutions.

Founding partner Joyce Hesselberth, a 1989 graduate of Virginia Commonwealth University, functions as art director, designer, and technical manager. Her design work has won numerous awards, including those from the Advertising Association of Baltimore, *HOW*, *Print*, and the New York Art Directors Club. Her illustration work has been seen in *Adobe Magazine*, *Business Week*, *Forbes*, *Reader's Digest*, and *The Washington Post Magazine*, and has won awards from the Society of Publication Design and American Illustration.

Other founding member David Plunkert, a 1987 graduate of Shepherd College, functions as art director, designer, and marketing director. Plunkert's graphic design work has won awards from, among others, the Advertising Association of Baltimore, *Communication Arts*, *Graphis*, *Print*, and the New York Type Directors Club. His illustrations have been seen in such publications as *Adobe Magazine*, *Forbes*, *Reader's Digest*, and *Time*, and have won awards from *Communication Arts* and the Society of Publication Design and American Illustration. Plunkert was included in the group show America Illustrata, which completed its international tour in 2000, and is a founding member of the Illustrators' Partnership of America.

In 2001, Joe Parisi joined Spur as a design partner and art director. A 1981 graduate of Towson University, Parisi has twenty years of experience as an award-winning graphic designer, with national design awards from *Communication Arts*, *Graphis*, *Print*, and the New York Type Directors Club, among others.

Spur has been featured in articles by *The Baltimore Sun*, *Graphis*, *Print*, and *Step-by-Step*. Several of Spur's posters are in the permanent collections of the Library of Congress, the Cooper-Hewitt National Design Museum, and the Museum for Kunst und Gewerbe in Hamburg, Germany.

Hatch poster

We hosted a gallery show of Hatch Show print posters, all of which have a country or country/western theme. For this announcement poster, Hatch Showprint created one side, Spur did the other. For our side, we used an old photograph of a country singer (or so we've assumed) that was hanging around our office. The picture, which had been given to us by a friend (who had in turn found it in an abandoned New Jersey hotel), was chosen as a representation of all country music as well as for its uncomfortable, unknown celebrity nature.

The photograph was scanned on our flatbed scanner, printed from our color printer, distressed and painted, and scanned back in again. The final poster was printed with a four-color process.

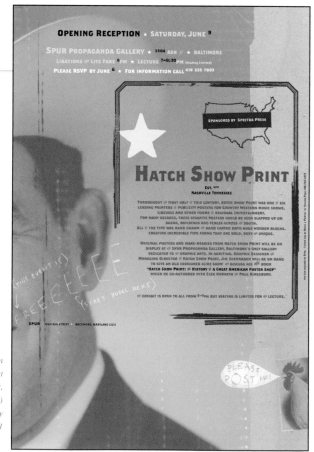

Studio: *Spur Design*
Art direction: *David Plunkert*
Design: *Joe Parisi, David Plunkert,*
Kurt Seidle, and Jim Sheridan (Hatch)
Client: *Spur Propaganda Gallery*
Year: *2001*

This poster was done for the Baltimore chapter of AIGA, which was hosting a panel discussion. The image of the worn hammer on broken pavement, combined with the heart motif, was meant to symbolize "building" or "designing" a life, with design considerations being secondary.

The image was shot on the sidewalk with 35mm black-and-white film on a sunny day, then scanned in as is and run as a duo-tone without computer manipulation. The type was created in Adobe Illustrator.

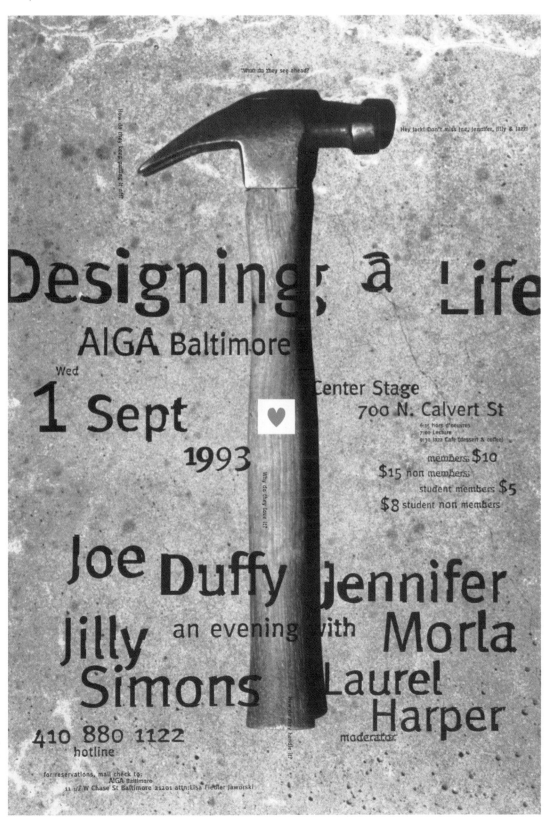

Studio: *Spur Design*
Art direction/Design: *David Plunkert*
Client: *Baltimore AIGA*
Year: *1993*

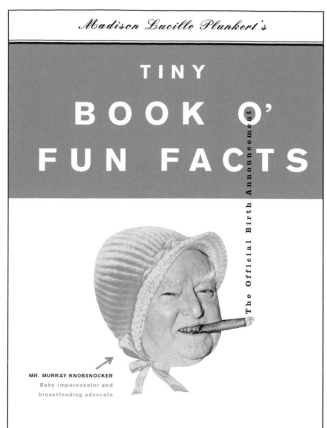

Madison Lucille Plunkert's

TINY
BOOK O'
FUN FACTS

The Official Birth Announcement

MR. MURRAY KNOBSNOCKER
Baby impersonator and
breastfeeding advocate

JOYCE HESSELBERTH
DAVID PLUNKERT
+ MADISON

4201 WALTHER AVENUE BALTIMORE MD 21214

TEL 410 319 8432

SPECIAL THANKS TO:
Lisa G. Rubin M.D., P.A.
The staff at GBMC
and all our family and friends

Procreated by Spur and printed by London Litho
Printed PMS Black & Baby Poop 118 on Hammermill 80# Linen Cover

Studio: *Spur Design*
Design/Copywriting: *David Plunkert*
Photography: *Joyce Hesselberth*
Client: *Independent project*
Year: *1999*

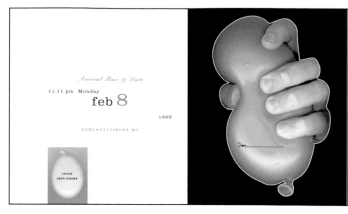

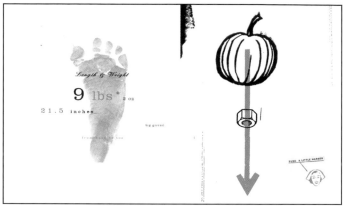

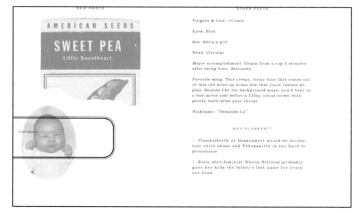

Madison Plunkert
birth announcement

We [Joyce and David] had a baby, so we decided to do a funny little book as a birth announcement. The images and objects used were chosen for their comedic content and accessibility (i.e., they didn't cost anything). The seeming randomness of the objects reinforces the fact-book tone of the booklet.

Images were found in our resource library of old books and magazines, and objects (like the hand squeezing the balloon) were scanned on our flatbed scanner. The booklet was printed in two colors on Hammermill linen.

Night in Havana invitation

Maryland Club is a private club in Baltimore. This invitation was for a members' party at the club, called "Night in Havana." We wanted the invitation to have the look and feel of Cuban street ephemera from Cuba's romantic heyday.

Cigar ads, old Cuban postcards, and the bottom of a cigar box—all collected from Spur's personal library—were scanned on our flatbed scanner and then cropped in unusual ways. The colors were half-toned using an Adobe Photoshop filter, and the images manipulated to exaggerate their toothiness. The piece was then printed with a four-color process on Tomahawk cover.

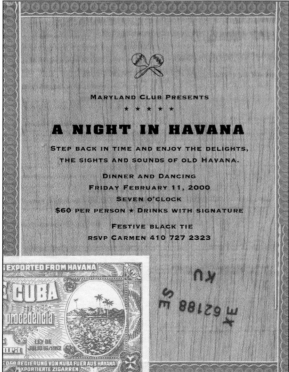

Studio: *Spur Design*
Art direction/Design: *David Plunkert*
Client: *Maryland Club*
Year: *2000*

Graham Peake and David Coventon founded TWO:DESIGN in 1997. Each had worked previously for a number of notable design and advertising agencies in London and had completed several underground projects, including award-winning hip-hop magazine *The Downlow*, for which Peake was a contributing designer.

Peake and Coventon started TWO:design with work for the music industry, notably for the Fugees, Will Smith, and Cypress Hill. The music industry remains a core focus of the studio's activity, though its portfolio has since expanded to include fashion, sports clothing, film, publishing, the arts, and new media.

Coventon, the studio manager, earned a B.A. in graphic design at Newcastle Polytechnic College of Art and Design and an M.A. in graphic design from Central Saint Martins. (Coventon was the first person ever to be selected from Newcastle to attend Saint Martins's graphic design M.A.

program, in which he attained a rare "distinction" grade.) Peake, the studio's art director, earned a B.A. in graphic design at Newcastle Polytechnic College of Art and Design and an M.A. in graphic design from Central Saint Martins. The team at TWO:design also includes Paul Wright (head of new media), Faizia Agha Khan, Paul Barton, and Tom Jeffs.

Proud to be a privately owned and independent limited company, TWO:design has few masters to serve, enabling its designers to concentrate on quality thinking, memorable ideas, and design creativity for their clients, and only their clients. The studio has been featured in numerous design articles and publications, including *Cool Type 2wo* (North Light Books, 1999), the Japanese magazines *plus 81* and *Webcreators*, and the Japanese e-zine *Shift*. In 1998 TWO:design received a British Phonographic Industry (BPI) award for its work on the UK marketing campaign for Will Smith's album *Big Willie Style*.

Tequila Sunrise CD packaging

If you have ever drunk tequila and lingered to consider the wider meaning of things, you may have occasionally seen a bubble appear in the glass—hence the inspiration for this cover. Creativity is core to Cypress Hill, a legendary hip-hop band; it would have been easy to fall into stereotypical covers for this CD, but our mission is to go one step further, even if we have to drink a lot of tequila to get there.

How does one find a bubble in a glass of tequila? Practice, practice, practice. Once the object was found (the bubble), we deliberately kept the photographer sober so that he could take the perfect shot on 2 1/4-inch transparency film. This was then scanned at a high resolution, retouched in Photoshop, and reduced to gray-scale for use in the artwork.

Studio: *TWO:design*
Art direction/Design: *Graham Peake and David Coventon*
Photography: *Richard E. Smith*
Client: *Ruffhouse/Columbia (for European territories)*
Year: *1998*

Fu-Gee-La promo packaging

This project–both the track and the resulting artwork–is about identity: how identity is perceived by individuals as well as how certain parts of the media want us to see it. Do we see the person first, or the race, or the gender? What we love about the Fugees is that they are not afraid to provoke a response, and they enjoy coming up with striking creative visual solutions.

Mike Davis, a freelance contact, let us "find" his hand and slap it on the scanner. It was then retouched in Photoshop and used in the artwork.

Studio: *TWO:design*
Art direction/Design: *Graham Peake*
Client: *Columbia Records (for European territories)*
Year: *1996*

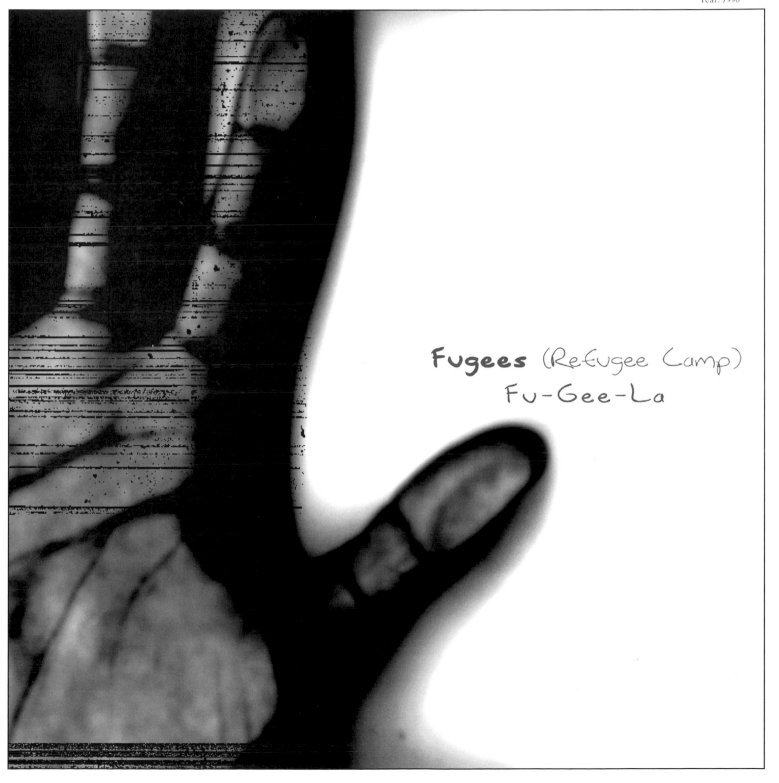

Fugees (Refugee Camp)
Fu-Gee-La

Legendary punk band Snuff is well known for experimentalism. With influences that range from northern soul to dub to reggae, the band's music features jumping-up-and-down guitars, screaming vocals, and driving bass. The northern soul/bowling alley culture inspired us and the Phase 9 bag was born, used in blue for the standard album, and in glorious camouflage for the remix dub album.

 The bag is an old bowling ball bag that was found in a thrift stall in London's massive Camden Markets, very near our studio. We photographed the bag on 35mm color transparency film and scanned it into Photoshop. The Stencil typeface was redrawn from sprayed signs on Camden's walls and streets, then added digitally.

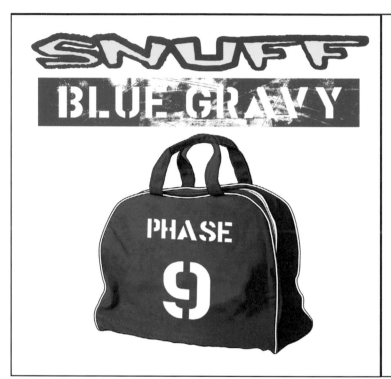

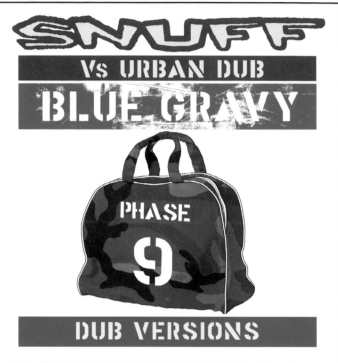

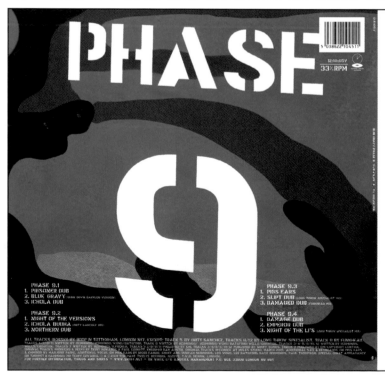

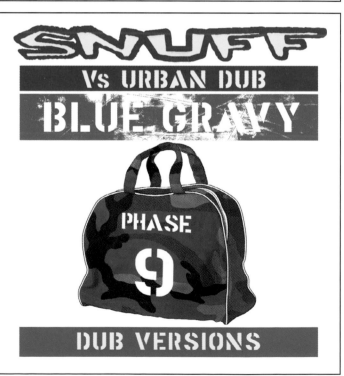

Studio: *TWO:design*

Art direction: *Graham Peake and David Coventon*

Design/Illustration: *Paul Wright*

Typography: *Graham Peake*

Photography: *TWO:design*

Client: *Ten Past Twelve Records/Fat Wreck Chords*

Year: *2001*

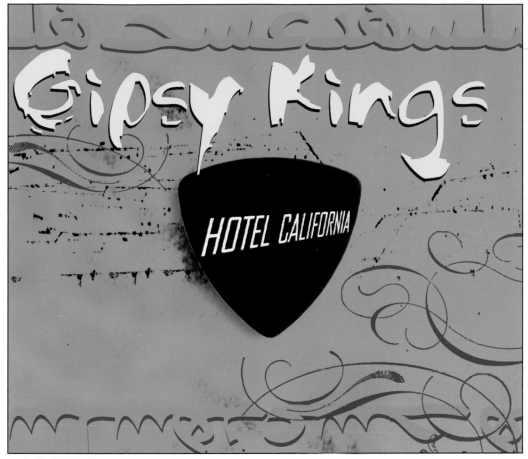

This packaging for the Gipsy Kings' reworking of the classic Eagles track needed to reflect the group's southern French roots and its foundation in traveling communities. We thought, "It's all about the guitars," and by chance came across a discarded plectrum on the streets of sunny Camden.

We scanned the plectrum directly on the flatbed, then added the text digitally in Photoshop. Although they're French, the Gipsy Kings are often assumed to be Spanish (possibly due to the slightly flamenco sound of their guitar playing). We played with this misconception, adding a background inspired by the work of Catalan painter Antoni Tapies. The flourishes and Arabic swirls were added for a Romany flavor, to represent the traveling communities from which the band comes.

Studio: *TWO:design*
Art direction/Design: *Graham Peake and David Coventon*
Client: *Sony Music/PEM*
Year: *1999*

Sertão Blues CD packaging

Slovo frontman Dave Randall (the ex-guitarist of Faithless) is well known for his collection of rare guitars, one of which is used on this track. The photo of the railway bridge in the background was taken by Dave Randall while on tour in Sertão, Brazil. The photo reflects the track: It's about the journey as much as the destination.

A shot of the back of Dave Randall's guitar was taken on 2 1/4-inch transparency film. It was scanned, cut out and retouched in Photoshop, and used in the art work. Dave's shot of the bridge was scanned in and retouched in Photoshop, then used for the background.

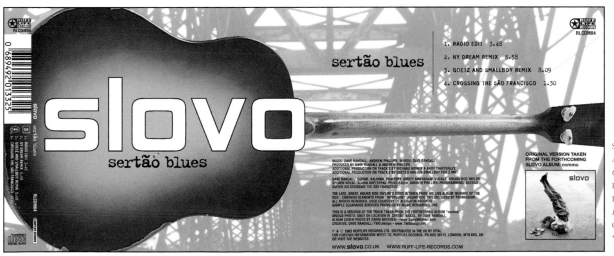

Studio: *TWO:design*
Art direction/Design: *Graham Peake and Dave Randall*
Logo design: *Paul Markham*
Photography: *TWO:design and Dave Randall*
Client: *Rufflife Records*
Year: *2002*

viktorKOEN

VIKTOR KOEN was born in 1967 in Thessaloniki, Greece. He holds a B.F.A. from the Bezalel Academy of Arts and Design in Jerusalem and an M.F.A. with honors from the School of Visual Arts in New York City. His work is regularly published in *The New York Times Book Review, Bloomberg Personal, Money,* and *Forbes.* Clients include Atlantic Records, Roadrunner Records, Delta Airlines, IBM, Random House, Doubleday Books, Penguin Putnam, Simon & Schuster, HarperCollins, *Men's Journal, Esquire, Fortune, Smart Money, Business Week, The Wall Street Journal, The Boston Globe,* and the *Chicago Tribune.* Koen serves on the faculty of Parsons School of Design and is a masters thesis advisor for the School of Visual Arts, both in New York City. His award-winning paintings, prints, and books are shown in galleries and museums in the United States, Europe, Japan, and Australia.

Devon

This is an interior, full-page, black-and-white image depicting Devon, the central character of the book *Sorcerers of the Nightwing*, published by Regan Books/HarperCollins. I wanted to create a compelling image that was dark (but not too dark), and to depict the main characters in an interesting way that would have staying power. (This was to be the first of a series of books with the same characters.)

The center of the composition is formed by the boy's face, which came from a vintage photograph, and its interaction with the building and sky, also from found photographs. The skull element was added for an aspect of mystery and to strengthen the image overall. A human skull was scanned directly on the glass and then combined digitally with the photographs. The elements are multilayered, each having been sized and adjusted for contrast, density, and transparency.

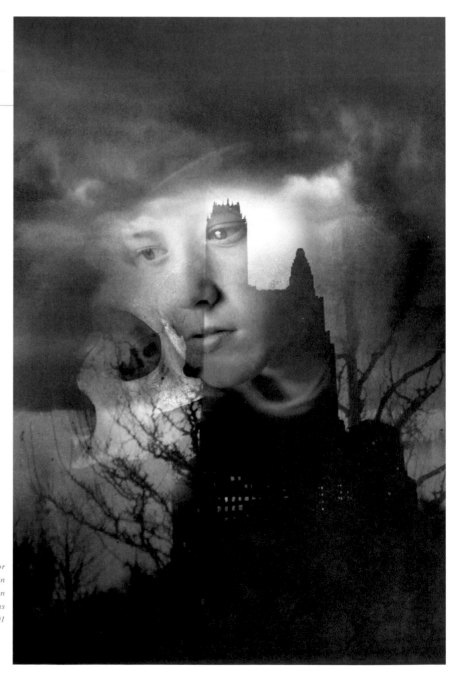

Art direction: *Dan Taylor*
Design: *Viktor Koen*
Illustration: *Viktor Koen*
Client: *Regan Books, an imprint of HarperCollins*
Year: *2001*

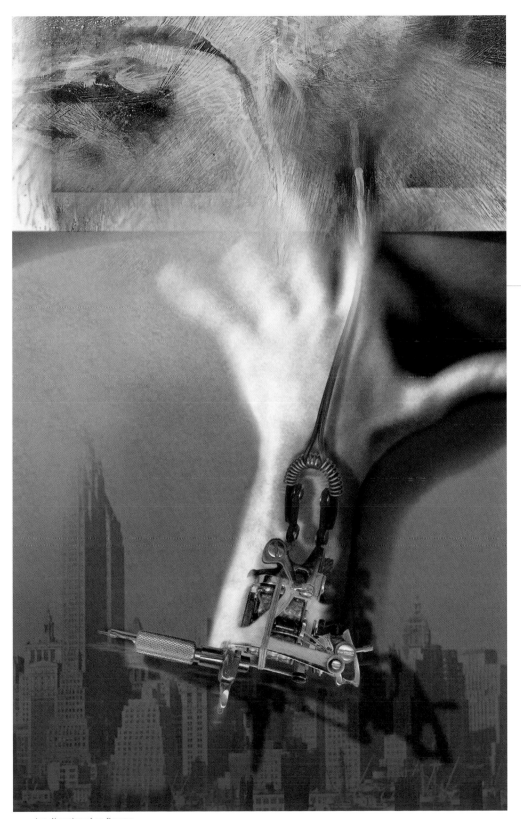

The Skin Within

This image was created for the invitation and poster of the exhibition The Skin Within: the Other Side of NYC Tattoo Artists at the Greeley Square Gallery, part of the third annual New York City Tattoo Convention. The image represents the fine-art strengths of tattoo artists, which was the focus of the exhibition.

Several tattoo guns were scanned directly on the glass and were combined to create the most photogenic gun possible. This image was then combined digitally with photographic materials, including a photograph of the New York City skyline (to reference the show's location) and a photo of a hand, which had a tense quality I found fitting for the subject. The painted elements are the edges of a scanned-in acrylic painting from my "Zodiac" series, done in 1988. The various elements were clipped, overplayed, tinted, and colored in Photoshop.

Art direction: *Les Barany*
Design: *Viktor Koen*
Illustration: *Viktor Koen*
Client: *Greeley Square Gallery*
Year: *2000*

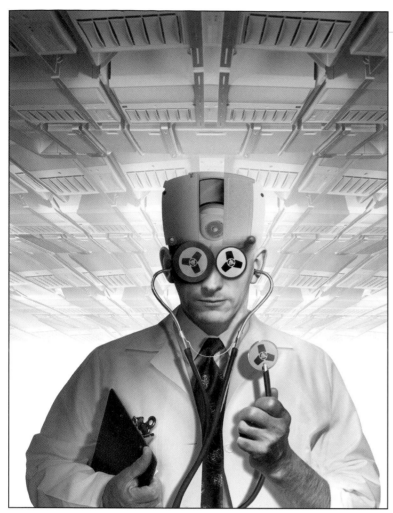

Backup Remedies

This full-page illustration for *eServer Magazine* accompanied an article about digital data recovery and backup problems and solutions. The central character, a "computer doctor," was compiled from various photographic sources to create the correct combination of face, white coat, sleeve position, and hand gestures. The overall design is based on this character's interaction with various computer disks I had lying around and a stethoscope (part of my collection of medical instruments), all of which were photographed digitally and then combined in Photoshop with stock photographic elements. The ceiling was composed by tiling and adjusting the size and perspective of a single computer part.

Art direction: *David Sather*
Design: *Viktor Koen*
Illustration: *Viktor Koen*
Client: *eServer Magazine, IBM*
Year: *2002*

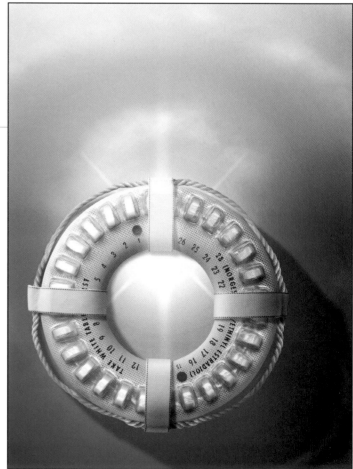

Birth Control in America

This cover illustration for *The New York Times Book Review* illustrated the subjects of two books: *Devices and Desires,* by Andrea Tone, and *Sexual Chemistry,* by Lara V. Marks. It was intended to portray a positive depiction of birth control. Contraception pills were scanned directly on the glass and then combined digitally with a photograph of a life preserver to create a hybrid object. The background was created from a fragment of a larger photograph of the sky.

Art direction: *Steven Heller*
Design: *Viktor Koen*
Illustration: *Viktor Koen*
Client: *The New York Times Book Review*
Year: *2001*

How the War Was Lost

For this *New York Times Book Review* cover illustration, for the two-volume book *Reporting Vietnam*, an exploding typewriter functions as a unifying device for original Vietnam war photographs. The typewriter was photographed conventionally, then combined in Photoshop with original Vietnam war photographs from from *The New York Times* archives.

Art direction: *Steven Heller*
Design: *Viktor Koen*
Illustration: *Viktor Koen*
Client: *The New York Times Book Review*
Year: *1999*

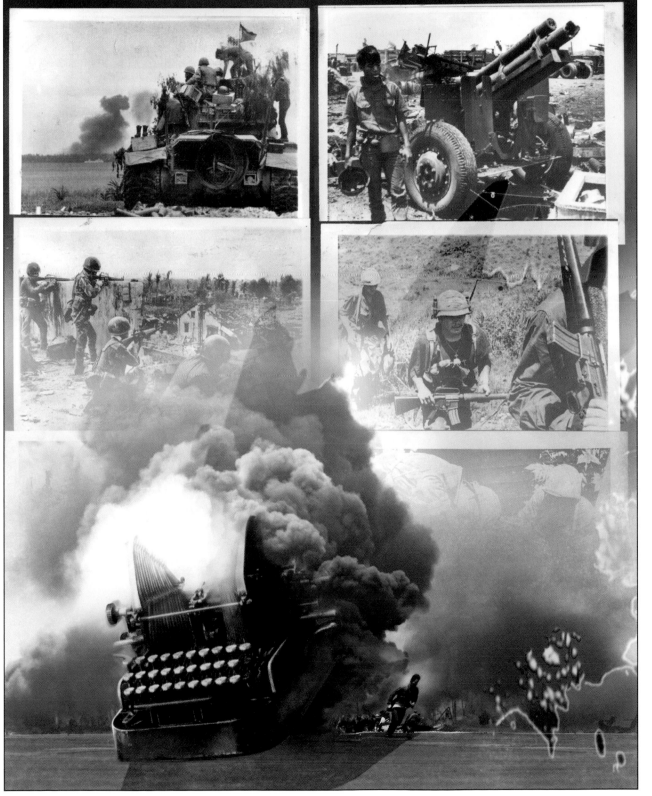

CHARLES WILKIN is the principal of Automatic Art and Design and Prototype Experimental Foundry in New York City. Wilkin founded Automatic in 1994 based on his belief that personal expression and professional application can and should interact as integral parts of the design process.

Wilkin's unique approach to design utilizes not only dialogue and strategy but also intuition and the human experience to develop visual solutions that are both engaging and memorable. The result is an emotive blend of art and design that interacts with its audience on multiple levels.

A native of Buffalo, New York, Wilkin graduated from the Columbus College of Art and Design with a B.F.A. in 1992. Over the past eight years, he has gained international recognition for his work with Automatic. He currently lives and works in New York City.

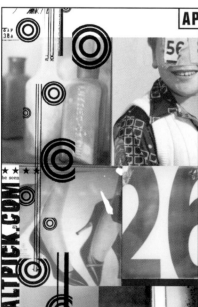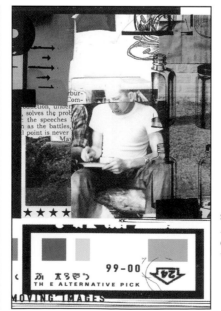

Alternative Pick postcards

This series of postcards for the Alternative Pick advertises various events and features found on its Web site, Altpick.com, a searchable database and forum for the creative industry. Many of the images and objects photographed on these cards were found at flea markets and antiques shops. The resulting images reflect the diversity of work shown on the site, including that of designers, illustrators, photographers, and filmmakers.

Most of the images were assembled by hand using tape and then color-corrected in Photoshop. The refined images were exported into QuarkXPress, where the type and remaining information was added.

Studio: *Automatic Art and Design*
Art direction/Design: *Charles Wilkin*
Client: *The Alternative Pick*
Year: *1999–2000*

Studio: *Olika, Firehouse 101, and Automatic Art and Design*
Art direction: *Lori Siebert*
Design: *Lori Siebert, Kirk Richard Smith, and Charles Wilkin*
Client: *Art Academy of Cincinnati*
Year: *2000*

Art Academy of Cincinnati admissions book

These two sample spreads are from the Art Academy of Cincinnati's 2000 admissions book, a collective project designed by Olika Design, Firehouse 101, and Automatic Art and Design.

In an effort to avoid the "corporate" feel such books often have, the Art Academy elected to pursue a different visual direction to better reflect its students and creative atmosphere; thus emerged the idea of basing it on a student sketchbook. This concept worked well with the school's reputation and emphasis on small class size, personal attention, and creative freedom.

Student and faculty were asked to submit their sketchbooks for use in the project. The selected art and excerpts from the sketchbooks (chosen by the design studios) was then incorporated into the book, along with type and other design elements.

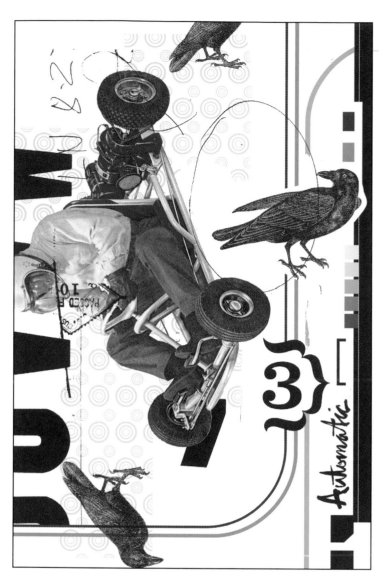

Go-Kart Go poster

This design was originally created for Automatic as part of a promotional mailer called Index-A. The mailer juxtaposed client and personal work as a means of showcasing Automatic's unique work ethic, which freely mixes fine art and design.

The go-cart image was taken from a 1950s farmer's catalog I purchased at a thrift store in Ohio. The crows were scanned from a book of clip art, and the circle pattern, type, and other graphics were created using Illustrator. All of the images were then imported into Photoshop and assembled using layers. The final image was exported and brought into the book's layout design in QuarkXPress. This image was also used later as an 18- by 24-inch promotional poster.

Studio: *Automatic Art and Design*
Art direction/Design: *Charles Wilkin*
Client: *Automatic Art and Design*
Year: *2002*

The Careful Reader

Originally for a flip-top cassette package patented by Bio-Box, this is one of eight collages created to loosely reflect the idea of making and personalizing a mixed cassette tape. All of the images were assembled first and then juxtaposed with edited quotes from a 1950s "inspirational" day planner I'd bought at a flea market. The result was a curious combination of images and text that not only embellished the original concept but also visually suggested something entirely new and unique.

The school photo was found and purchased specifically for this project at an antiques shop in Columbus, Ohio. The type, text, and buttons were extracted from magazine ads found in various 1950s magazines in my archives. The image was assembled by hand with tape, then scanned and color-corrected in Photoshop. The final image was placed in Illustrator and laid out according to the box template furnished by the client.

Studio: *Automatic Art and Design*
Art direction/Design: *Charles Wilkin*
Client: *Bio-Box/TVT Records*
Year: *1998*

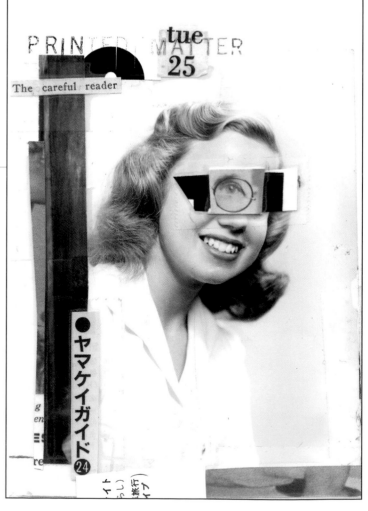

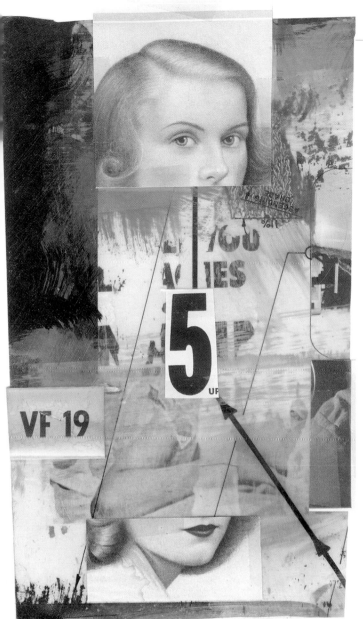

Red Number 5

This design was done as an experiment in mixed media, combining paper collage, oil paint, and photocopies. The images were pulled from my archives. As I prefer to let the meaning and concept of my assemblages evolve out of the creative process and the objects themselves, rather than specifically seeking out images or objects for each project, I am continually collecting magazines, photographs, and objects for my archives. The images used here had been extracted from 1950s magazines found at antiques shops, while the acetate blueprint in the background was purchased at a garage sale.

The photo images were assembled and adhered to the acetate blueprint with tape and matte medium. Oil paint was later applied to the front and back of the acetate. The whole thing was then mounted to newsprint paper with matte medium.

Studio: *Automatic Art and Design*
Art direction/Design: *Charles Wilkin*
Client: *Independent project*
Year: *1998*

Capitol Records ad

This ad for Capitol Records was created for the 1998 MTV Video Music Awards booklet, distributed the night of the awards show. The image was based on a series of four words faxed to me by MTV Creative Director Tommy Steele, which represented the theme "music makers." All of the elements were extracted from various catalogs, magazines, and clip art—all from the 1930s, '40s, and '50s—that I'd purchased at flea markets and thrift stores over the years.

The original art was first created by hand and assembled with clear tape. It was then refined in Photoshop. Unwanted type, elements, and moiré patterns were removed; color was adjusted; images were sharpened. The refined image was then imported into QuarkXPress, where the logo and stars were added.

Studio: *Automatic Art and Design*
Art direction: *Tommy Steele and Jeff Fey*
Design: *Charles Wilkin*
Client: *Capitol Records*
Year: *1998*

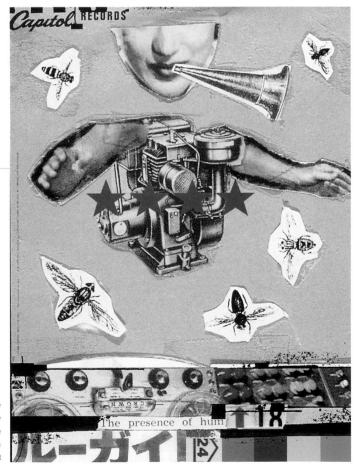

boyzandGIRLS

Founded by Anselm Dastner in 1994, New York City–based design studio BOYZandGIRLS specializes in print and Web graphics for the music and nightclub industries. Other clients include Sony, MTV, and Adidas. The studio cofounded *FlyerNYC*, New York's premier urban culture guide (circulation fifty thousand) and continues to be deeply involved in the music scene, often hired by top promoters at underground parties and world-famous megaclubs for fresh designs that attract the right audience. Many of the studio's event flyers have achieved legendary status. BOYZandGIRLS also works closely with New York's most prestigious underground record labels, including Ibadan Records, Wave Records (Body & SOUL), Spiritual Life Records, and Oscar Poche's MediaServicesNYC.

BOYZandGIRLS maintains a strong alliance with Munich-based Cream01 Federation, a full-service brand management firm.

Tag Story

This portfolio project was designed for the Web-based magazine at Cream01 Germany. The design was intended to document, recognize, and preserve a piece of New York's Lower East Side culture. As designed for the Web, thumbnails of the tags served as roll-overs laid on top of a street map.

Traditionally, "tagging" is nametag graffiti, in which initials are "thrown" onto outside walls quickly and in quantity—a way for street gangs to mark their territories. On the Lower East Side, however, as young artists have moved into the neighborhood, the style has been adapted into a means of reclaiming the streets with art. The standard spray-cans and markers have evolved into a diverse array of materials, including stencils, stamps, silk screens, colored tiles, and plastic moldings.

Tags are more than street art: They are social commentaries, and they almost always tell in-depth stories as the artists go to ingenious lengths to display their work on the streets. Some tag crews are legendary, such as IRak ("I rak" stands for "I steal"), Bäst, and the artist Spaceinvader, with his trademark notebook-sized mosaics on walls around New York City, Paris, and Tokyo. Almost every graffiti tag artist claims that others are copying his or her style.

Every now and then, hostilities between rival graffiti crews are manifested by crossing out, or "buffing," another crew's tag with immature or even threatening comments, such as "TOS," which stands for "terminate on sight." The bolder and more dangerous the locations of these tags and cross-outs, the higher the respect accorded to the artist or crew.

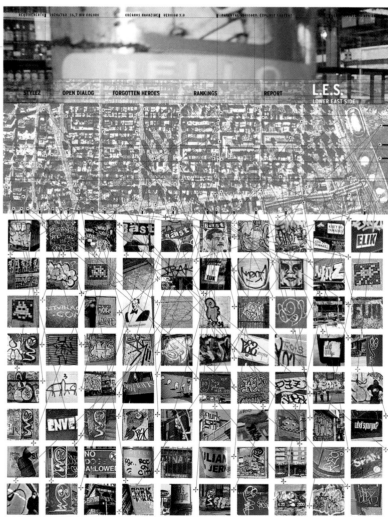

Studio: *BOYZandGIRLS and Cream01 NYC*
Art direction: *Cooperation with Cream01 NYC*
Design/Photography: *Anselm Dastner*
Client: *Independent project*
Year: *2001*

Door Story

This photo collage was another design intended for the Cream01 Germany's Web-based magazine, this one an exploration of the Lower East Side's doors. Textures of the street have always fascinated me, and New York City's Lower East Side is full of them: signs, posters, cracks, walls, lampposts, awnings—all covered with graffiti. One of the neighborhood's streets, Bowery Street, has a particularly unique reputation. Lined with Chinese kitchen supply stores, it becomes dark and empty at night—ideal conditions for street artists. There are no cops to interfere, and the graffiti lasts longer than in other parts of the city, where neighbors tend to quickly over-paint.

As I walked around taking pictures with a digital camera, I defined a "good" door as one covered top to bottom with scribbles made with markers or crayons, referred to as "throw-ups." The sites continue into the adjacent neighborhoods of NoLita and SoHo. Once I had the images, I digitally rebuilt the background in Illustrator to create the impression that the viewer was looking into a video game screen.

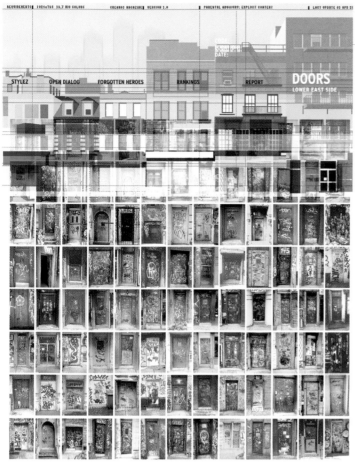

Studio: *BOYZandGIRLS and Cream01 NYC*
Art direction: *Cooperation with Cream01 NYC*
Design/Photography: *Anselm Dastner*
Client: *Independent project*
Year: *2001*

Roof Story

This design, an exploration of New York City's largely unseen rooftops, was a third submission to the Cream01 Germany Web-based magazine.

New Yorkers often complain that there is little open sky to be seen from within the canyons of the streets' buildings. But in fact, the city's roofs, largely unexplored, are inspirational places to relax from the busy street life. It feels good to let the eyes wander into the far distance, and the view of New York's skyline is always beautiful; in this picture, you can still see the World Trade Center.

To fill this void, I decided to map out my favorite panoramic sites from roofs around the neighborhood and suggest a list of them on the Web, ideally with a live Web-cam. Digital and old photos were layered in Photoshop to form the collage. The stripe in the middle is a panoramic view over Manhattan, taken from my roof. On the Web, one can zoom into the skyline to see details, as well as browse through the many pictures of roof party guests. The top picture shows a friend's shoes casting a shadow in the early morning sun.

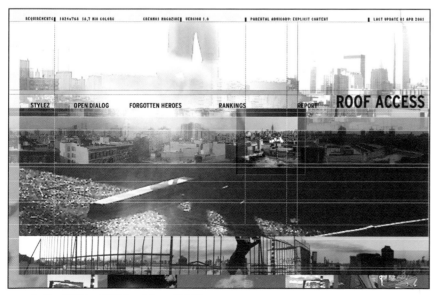

Studio: *BOYZandGIRLS and Cream01 NYC*
Art direction: *Cooperation with Cream01 NYC*
Design: *Anselm Dastner*
Photography: *Anselm Dastner and Nina Schlechtriem*
Client: *Independent project*
Year: *2001*

Nectar flyer

This poster was intended to promote a weekly party called "Nectar" (later renamed "Pollen") at a Washington, D.C., music club. I did more than thirty monthly flyers for this party, all transported via Internet.

For the background of this flyer, I bootlegged a Snapple iced tea bottle, because the drink's vitamin C and sugar are rave essentials, just like nectar. The bug and flower graphics amplify the psychedelic look.

Studio: *BOYZandGIRLS*
Art direction: *Sina Mollaan*
Design: *Anselm Dastner*
Client: *The Edge*
Year: *1997*

It's a great challenge to design a flyer for a party that all of your friends attend. This poster was to promote a monthly party featuring DJs who spin fast mixes of breakbeat records. I wanted the images to create a joyful reaction, which brought me to the idea of using toy racetracks, which excited me as a kid (and still do today).

For our first flyer, speedy graphics and grooves of curving vinyl tracks were used to suggest a DJ without resorting to over-used turntable graphics. (After browsing through toy catalogs for pictures, it was all we could do to keep ourselves from ordering a racetrack to set up in the office!) For the next month's flyer (shown here), we chose to reference the first episode of a 1960s TV puppet show called *Thunderbirds*. I had worked on the re-released DVD set of the show and had become a fan of the series. In the first episode, the landing gear of a supersonic jumbo jet fails and small transporters of the international Thunderbird rescue team are brought in to prevent a crash. I redrew most of their many rockets and crafts in Illustrator.

I tried to keep all of the graphics in Adobe Illustrator so that I could quickly send the files through the Internet to the printer; the flyers would be printed and distributed that same night.

Studio: *BOYZandGIRLS*
Art direction/Design: *Anselm Dastner*
Client: *Cliff Seoul (Direct Drive)*
Year: *2002*

CHASEdesignGROUP

Margo Chase is founder and creative director of CHASE DESIGN GROUP, where she enjoys helping client companies become more successful. Chase Design Group is about clear-seeing strategy and award-winning design, applied to identity, print, packaging, advertising, and motion graphics. Margo Chase believes that every design product should move its audience in a way that delights the eye and inspires the mind.

Among new work from this ever-busy firm, look for a re-tuned corporate identity at USA Networks, new television identities for *Birds of Prey* and *The Wizard of Oz*, brand planning work and ad campaigns for Mattel, and—wildly enough—identities and interiors for lingerie stores in Mecca and Jeddah, Saudi Arabia.

Aerosphere birdhouses

These birdhouses were made for an auction sponsored by the Los Angeles AIGA. The organization provided wooden birdhouses to several designers, artists, and architects, asking each to create a unique birdhouse by either decorating the one provided or starting from scratch. We chose to start from scratch and design the ultimate high-tech house for the modernist bird.

All of the components were found at our local hardware store. The glass spheres are replacement globes for standard light fixtures. They were attached to bathtub chains with chrome drawer-pulls glued on upside down. Three matching houses were suspended from a branch painted white. The design process was a collaboration between senior designer Jonathan Sample and I. We spent several hours walking up and down the aisles at the hardware store looking for things that would function and look good without costing too much. I think Jonathan's suggestion of the drawer-pull as connector was an especially creative leap.

Studio: *Chase Design Group*
Art direction: *Margo Chase*
Design: *Jonathan Sample*
Photography: *Margo Chase*
Client: *Los Angeles AIGA*
Year: *2002*

Witch's Brew book design

This series of six books was designed for Chronicle Books. All of the books' spells were written by a white (Wicca) witch, and include recipes for everything from winning the love of a stranger to getting a good job. Our book design was to make them look authentically witchy, but not too creepy.

There was no budget for photography or illustration, so we did all of the illustrations in-house. Each book has eleven collages that use all kinds of found objects, including plants, roots, stones, and whatever else was lying around—one even includes a dead snake found by my gardener. (I'd kept the snake in my freezer for several years and finally thawed it out for this project.) Each collage was made by arranging the found objects on the glass of our flat-bed scanner. The scans were taken into Photoshop, where aged paper backgrounds and line art were added to create the final collages.

Studio: *Chase Design Group*
Art direction/Design: *Margo Chase*
Illustration: *Margo Chase and Husam Khalil*
Client: *Chronicle Books Gift Works*
Year: *2000*

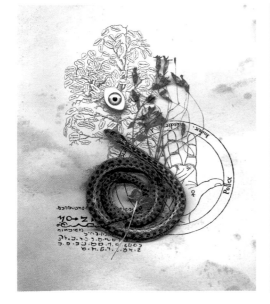

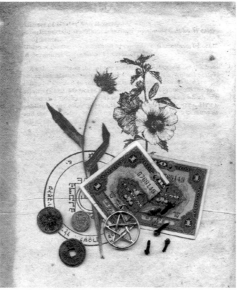

Studio: *Chase Design Group*
Art direction: *Margo Chase*
Design: *Jonathan Sample and Margo Chase*
Client: *LOIS/EJL for Pacifico Beer*
Year: *1998*

Pacifico print ads

Advertising agency LOIS/EJL contacted our studio for custom letterforms and retro texturing to be used in vintage-style 1960s and '70s "surfing" print ads for Pacifico beer. It was decided that a large part of Pacifico's market had been neglected in previous campaigns: the surf-savvy consumer who resides in southern California. LOIS/EJL hoped to connect with that market via print ads in popular magazines as well as a billboard campaign that ran specifically in southern California.

Being a West Coast studio with designers born and raised in southern California in the 1960s and '70s proved valuable for this job. Digging through boxes of childhood memorabilia,

designer Jonathan Sample found resource materials that drove the design, from letterforms and color palette to textures and materials. Sample used surf magazines from yesteryear for inspiration, to give the headline letterform type a genuine surf-retro feel. After many rounds of sketches and legibility tests, LOIS/EJL chose whimsical, interlocking letterforms that they felt captured the retro vibe. The campaign was strengthened with the addition of 1960s period backgrounds, achieved by scanning a grass mat acquired on a tropical vacation, and re-creating the wood grain of a surfboard abandoned in Jonathan's garage.

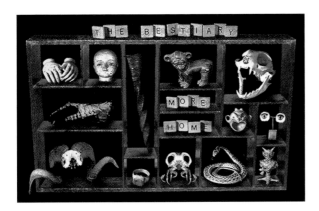

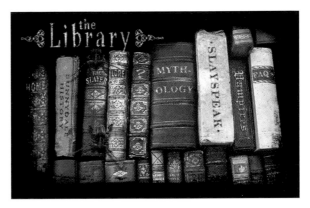

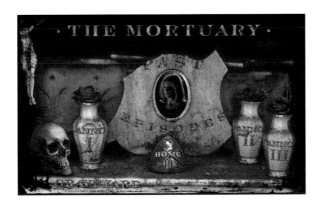

Studio: *Chase Design Group*
Art direction: *Margo Chase*
Design: *Jonathan Sample, Chris Lowery,*
Brian Hunt, and Margo Chase
Photography: *Margo Chase and Chris Lowery*
Client: *WB Television Network*
Year: *1999*

www.buffy.com

We designed a Flash Web site for the WB network's television show *Buffy the Vampire Slayer*. They wanted a creepy "immersive experience" for the show's fans. We created a number of interactive navigation pages that use found objects as icons linking different sections.

Several of the objects are animations triggered by roll-over. To get all of the frames we needed for the animations, we photographed the objects with a digital camera in "stop action" style:

taking a shot, moving the object slightly, taking another shot. Several objects were grouped and assembled on "shelves," which were built and photographed for the purpose. On the library navigation page a bug walks over the books. He was "found" outside and performed his role without complaint. (He's not a SAG member so we didn't have to pay him scale.) The dead snake, used earlier in the *Witch's Brew* books (page 57), was thawed out a second time, and a cat skull from my collection made its debut.

CHIP KIDD works as a writer and graphic designer in New York City. His book jacket designs for Alfred A. Knopf, where he has worked since 1986, have helped spawn a revolution in the art of American book packaging. His work has been featured in *Vanity Fair, Print* (cover story), *Entertainment Weekly, The New Republic, Time, The New York Times, Graphis, New York,* and *ID.* The latter chose him as part of its first "ID 40," a group of the nation's top designers, and has twice awarded him "Best of Category, Packaging."

Kidd's designs have been described as "monstrously ugly" (John Updike), "apparently obvious" (William Boyd), "faithful flat-earth rendering" (Don DeLillo), "surprisingly elegant" (A. S. Mehta), "a distinguished parochial comic balding Episcopal priest" (Allan Gurganus), "two colors plus a sash" (Martin Amis), and "not a piece of hype. My book was lucky" (Robert Hughes). In 1997 Kidd received the International Center of Photography's award for use of photography in graphic design. In 1998, he was made a member of the Alliance Graphique Internationale. He was also recently made an official member of the Drama Department, the distinguished off-Broadway theater company run by playwright Douglas Carter Beane.

Kidd has written about graphic design and popular culture for *Vogue, The New York Times, The New York Observer, Entertainment Weekly, Details, Arena, 2WICE, The New York Post, ID,* and *Print.* He is a regular contributor of visual commentary to the op-ed page of *The New York Times,* and has served as design consultant to *The Paris Review* and *The Yale Review* since 1995. His first book as author and designer, *Batman Collected* (Bulfinch, 1996), was given the Design Distinction award from *ID* magazine; his second, *Batman Animated* (HarperCollins, 1998) garnered two of the comics industry's Eisner awards. *The Cheese Monkeys,* Kidd's first novel, was published by Scribner in 2001 and was a national best-seller as well as a *New York Times* Notable Book of the Year.

Studio: *Chip Kidd Design*
Art direction/Design: *Chip Kidd*
Client: *Alfred A. Knopf*
Year: *2001*

The Little Friend

I found this old 1930s doll's head at a friend's art studio. I knew that with the right lighting and focus it would convey the sense of dread and creepiness that permeates this novel by Donna Tartt. It also made sense given the book's title.

Studio: *Chip Kidd Design*
Art direction/Design: *Chip Kidd*
Photography: *Geoff Spear*
Client: *Alfred A. Knopf*
Year: *2002*

The Darkness and the Light

This collection of Anthony Hecht's poetry, which speaks to both the ancient world and World War II, is perfectly suited to the comparison and contrast of a Renaissance fresco and an old newspaper photograph.

Paperboy

In this memoir, author Henry Petroski evokes his 1950s boyhood in Queens, where he belonged to a guild of paperboys—thus the 1940s copy of *The New York Times*. I wanted to make the book look deliverable.

Studio: *Chip Kidd Design*
Art direction/Design: *Chip Kidd*
Photography: *Geoff Spear*
Client: *Alfred A. Knopf*
Year: *2001*

Seek My Face

For the cover of John Updike's *Seek My Face*, a novel set within the context of postwar American art, I wanted to use a painting that was half abstract, half not. The best way to do this was to show an extreme close-up detail—this one is of a painting found in a flea market. This is the only jacket (so far) that Mr. Updike has allowed me to design completely on my own.

Studio: *Chip Kidd Design*
Art direction/Design: *Chip Kidd*
Client: *Alfred A. Knopf*
Year: *2002*

Minority Report

In this short story, which inspired the movie of the same name, a police commissioner has to fight the very crime-prevention system he created when the system's psychic "precogs," hired to stop crimes before they happen, tag him as a soon-to-be murderer. This scan of a plastic figure's head is only recognizable as a head if you open the book all the way and hold it upside down (though why you would do that is anyone's guess).

Studio: *Chip Kidd Design*
Art direction/Design: *Chip Kidd*
Client: *Pantheon*
Year: *2002*

The Catsitters

James Wolcott's novel follows an out-of-work actor as he navigates the cutthroat New York City dating scene. We used a ravaged cat-toy.... What more is there to say?

Studio: *Chip Kidd Design*
Art direction/Design: *Chip Kidd*
Photography: *Geoff Spear*
Client: *HarperCollins*
Year: *2000*

Depraved Indifference

Author Gary Indiana's kinetic novel follows a sociopathic Las Vegas grifter named Evangeline. I used this old Polaroid, found at a flea market, because it looks depraved...and indifferent.

Studio: *Chip Kidd Design*
Art direction/Design: *Chip Kidd*
Client: *William Morrow*
Year: *2001*

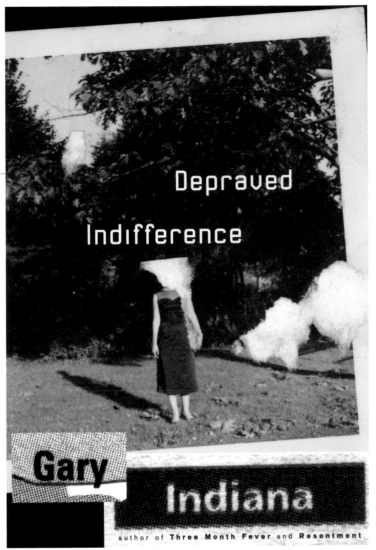

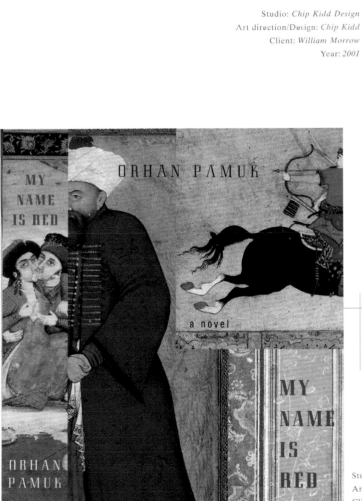

My Name Is Red

For this novel—set in Istanbul in the waning days of the Ottoman Empire—I deconstructed fifteenth-century Turkish miniatures to tell a narrative that didn't originally exist, which is pretty much what the author does in the text as well.

Studio: *Chip Kidd Design*
Art direction/Design: *Chip Kidd*
Client: *Alfred A. Knopf*
Year: *2001*

CREAM 01 FEDERATION was founded as a creative organization in 1999 by Cyrill Gutsch and Jules Rembold. Although headquartered in Munich, Cream01 employs media artists, designers, writers, and scientists in the fields of art, media, and communication all over Europe and the United States. Cream01's clients include such brands as Adidas, Levi's, Payback (Lufthansa), AOL Time Warner, and Columbia Tristar. In 2001, Cream01 and the J. W. Goethe University of Frankfurt founded the Center for Media at Frankfurt University (CCID) as an institute for education and research in the fields of media design, media theory, and communications.

Construction Field

This artwork was created for an exhibition at CCID and the J. W. Goethe University in Frankfurt. The designer collected artifacts on construction fields; by seeing these artifacts in an abstract way or from a new perspective, you discover even in the most worthless piece of trash an individual value.

Studio: *Cream01 Federation*
Design/Photography: *Cyrill Gutsch*
Client: *CCID at J. W. Goethe University, Frankfurt*
Year: *2001*

Indestructible Memory

Impressions are constantly brought to us by the daily news—impressions that you cannot delete from your mind. Without being aware of it, these moments help build your reality. You cannot forget them.

Studio: *Cream01 Federation*
Design: *Jules Rembold*
Client: *Independent project*
Year: *2001–2002*

Tête-à-Tête typo kit

On the basis of a found receipt from a restaurant in Munich, the designer developed the Tête-à-Tête typo kit, which makes social interaction easy and direct by offering a ready-made repertoire of chat-standards, also called "speech boobles." Tête-à-Tête can be used as a font in handhelds, e-mails, or any other digital device. The typeface was developed in Fontographer.

Studio: *Cream01 Federation*
Design: *Lea Stepken*
Client: *Independent project*
Year: *2002*

Digital Trash as Obituary of Human Life

This work examines cultural change in our society and questions the thoughtless use of digital communication technology. Assuming that digital information would survive a physical collapse of planet Earth, the work focuses on digital knowledge and the protection of a digital memory of human culture.

The Data Recovery Module (DRM), an interactive media sculpture made of aluminum, represents a cybernetic part of the mothership. Should planet Earth experience a complete system crash, the DRM would assemble itself and recover important digital cultural data. It is the cultural backup system (the "disc doctor") for planet Earth.

Other images shown here represent data recovered by the DRM, stored on optical data carriers specifically intended to contain restored cultural information. Each image was created on computer, then printed in layers on transparent film (Cibachrome). The layers were pasted together and set atop a custom-made light source, then photographed.

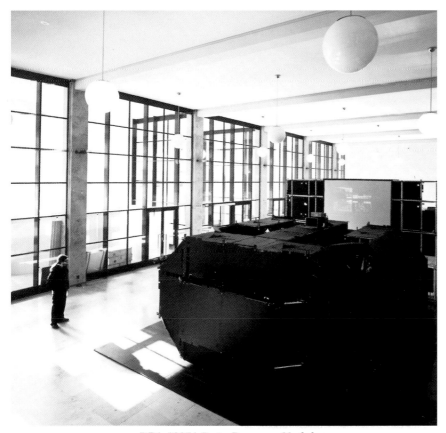

DR1-18971 Data Recovery Module

2b-Butterfly. Visual representation of data recovered by the DRM, stored on optical data carriers. Type: Animals

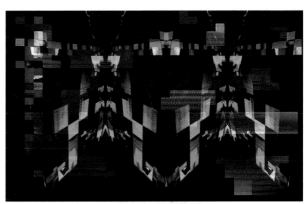

Crystal Palace. Visual representation of data recovered by the DRM. Type: Architecture

Bloodtype MUG. Visual representation of data recovered by the DRM. Type: Genetics

Studio: *Cream01 Federation*
Design: *18971@cream01*
Photography: *Giovanni Castell and Jules Rembold*
Client: *Independent project*
Year: *2001*

alexander GELMAN

ALEXANDER GELMAN is one of today's most influential and innovative designers. His work, which utilizes traditional graphic design, fine arts, and interactive media, is housed in the permanent collections of MoMA and the Cooper-Hewitt National Design Museum in New York City. As a founder of Design Machine, his cross-disciplinary design consultancy, he has produced designs for such brands as Absolut Vodka, MTV, IBM, Shiseido, United Airlines, and Swatch. He contributes regularly to *The New York Times* and is the author of *Subtraction*, the best-selling book on his unique design philosophy. Gelman also teaches at Cooper Union and Yale.

Do or Die identity system

The client, a hip-hop clothing company in Germany, needed a new, in-your-face identity. A found bullet provided the perfect inspiration. All type was die- or laser-cut to look like bullet holes. We used a bullet for reference, creating the rendering in Adobe Illustrator.

Studio: *Design Machine*
Art direction: *Alexander Gelman*
Design: *David Heasty*
Client: *Do or Die*
Year: *2001*

555 poster

In this poster for the 555 gallery, a familiar object—a die—loses its functionality, becoming instead a symbol for the client and inspiring a novel identity. With a simple change, the die stops being a die and becomes a tool to communicate the client's name. Using a die as the model, the final image was created in Adobe Illustrator.

Five Fifty Five

Studio: *Design Machine*
Art direction/Design: *Alexander Gelman*
Client: *555 Gallery*
Year: *1997*

Untitled advertisements

For this advertising campaign for Untitled, a catalog of alternative stock photography from the United Kingdom, we chose to cast aside the obvious—images from the catalog—and instead focused on the catalog itself, its physical qualities as an object. We simply scanned the catalog as found, without any manipulation at all.

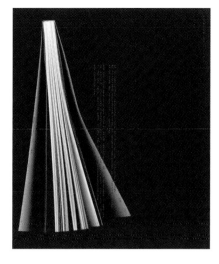

Studio: *Design Machine*
Art direction: *Alexander Gelman*
Design: *Karin Satrom*
Photography: *Alexander Gelman*
Client: *Untitled*
Year: *2000*

Future Nonstøck identity system and logo

This logo/identity/typeface was done for Future Nonstøck, a nonprofit program that promotes young photographers. A frame from a 4- by 5-inch transparency provided the logo, and the matrix typeface on the transparency inspired the entire corporate typeface. The logo is always produced actual size on identity applications. After finding a suitable transparency, we scanned it and rendered the final logo in Illustrator.

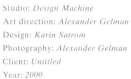

Studio: *Design Machine*
Art direction: *Alexander Gelman*
Design: *David Heasty*
Client: *Future Nonstøck*
Year: *2001*

Bicycle Lamp

The client, World Studio Foundation, asked us to design a lamp for them to sell in their annual auction to raise money for design scholarships. All participants were given a generic lamp that they could decorate or redesign.

Our design focused on this bicycle; when parked in the living room of a small apartment, a bicycle instantly becomes a furniture object. People hang clothes, stack magazines, and place other stuff on it. Even pedals serve as shelves for small things. When turned into such a universal interior object, a bike lacks only one thing: a light source. To accommodate that demand we designed an extension that adds functionality and reason, turning the bicycle into a lamp. The brass shaft of the lamp fit perfectly into a readily available children's bicycle.

Studio: *Design Machine*
Art direction: *Alexander Gelman*
Design: *David Heasty*
Client: *World Studio Foundation*
Year: *2001*

It's a rare opportunity when the new year echoes the most frequently advertised price in American consumer culture. This holiday greeting, done for our studio, appropriates the visual language of the supermarket and raises awareness of a consumer landscape based on $.99. Our goal was to create a generic representation informed by the language of retail signage.

Studio: *Design Machine*
Art direction: *Alexander Gelman*
Design: *David Heasty*
Client: *Design Machine*
Year: *1998*

amesDESIGN

AMES DESIGN opened its doors in 1995, when Coby Schultz and Barry Ament decided to make a go of it on their own. The duo's first job was a poster, a design form that has done much to keep their doors open for almost eight years. Both Schultz and Ament moved to Seattle in the early to mid-1990s, an exciting time for show posters. The studio's early screen-printed posters for local rock bands, including Pearl Jam, were artful enough to inspire local storeowners to put them in their windows. Early on, the Ames design crew also began creating hand-crafted snowboard graphics for K2 Snowboards.

Ames's client list now boasts the likes of Pearl Jam, MTV, Got Milk, Nissan, Phish, K2 and Ride Snowboards, Nike, Amazon.com, Powerbar, and Absolut—to name a few. The firm's work has been widely published in books and magazines, has won several design awards, and landed a Grammy nomination for the packaging design of Pearl Jam's 1998 CD and album, *Yield.*

Amidst the hype of modern design and computers, Ames continues to generate most of its designs by hand, viewing computers as tools that should never be allowed to dictate a design. This is especially evident in their portfolio of intricate snowboard graphics and silk-screened tour posters.

Ames Christmas invite

We wanted to create a memorable invitation for our annual Christmas party, so we decided to send out a keepsake that people would hold onto long after the party. The tree, being the ultimate symbol of Christmas and holiday cheer, led us to the all-mighty air freshener. We decided to replace the air freshen-er's packaging with our invite information, which was created in Illustrator. Once we'd cleaned out every auto parts store in town to find three hundred air fresheners, the assembly proved quite easy. Scissors, a glue stick, and a hole punch gave us what appeared at first glance to be the real thing.

Studio: *Ames Design*
Art direction: *Barry Ament and Mark Van S.*
Design: *Barry Ament*
Illustration: *Barry Ament*
Client: *Ames Design*
Year: *1998*

Pearl Jam Vitalogy
CD packaging

We wanted to push CD packaging and mess with the standard format. Eddie [Vedder, of Pearl Jam] found an old turn-of-the-century book called *How to Practice a Vital Life*. We basically gutted the book, and cut and pasted its contents along with song lyrics and other scraps. It was completed in two days and was very raw and rough around the edges. We wanted the viewer to know we'd cut up an old book, not to think that we'd created it ourselves.

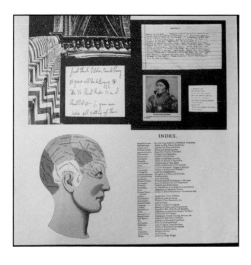

Studio: *Ames Design*
Art direction: *Ed Vedder and Joel Zimmerman*
Design: *Joel Zimmerman, Ed Vedder, and Barry Ament*
Photography: *Lance Mercer and Jeff Ament*
Client: *Pearl Jam*
Year: *1991*

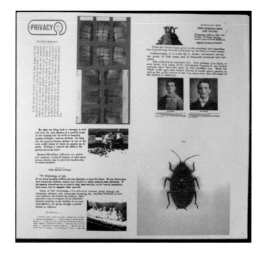

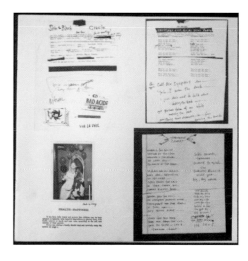

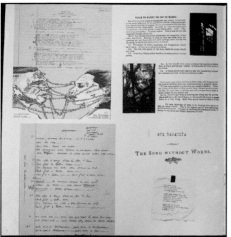

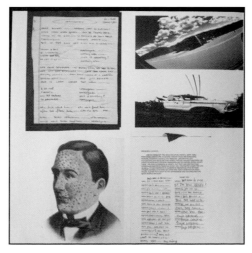

Pearl Jam Fan Club
Newsletter #14

This was to be an issue of a twice-yearly mailer sent out to thirty thousand fans and members of Pearl Jam's fan club. We wanted to make it a keepsake, so we incorporated a monthly calendar into the newsletter.

This was the first time we had been given a budget to do a four-color job, but because Pearl Jam never wants to be seen as an elegant, high-gloss product, we decided to keep the design very raw and rough around the edges and focus on the ugliness and flaws of the four-color process (such as dot patterns and missed registration). We used the cheapest paper available, and even requested that the printer throw a sandwich into the press while running our job. Artwork was inspired by items like candy wrappers, food packaging, and spark plug packaging, which were incorporated into each calendar.

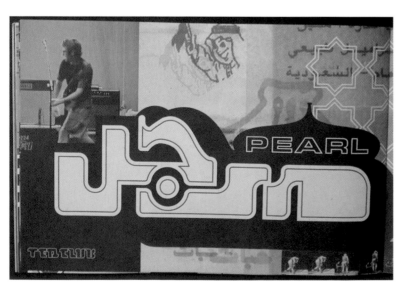

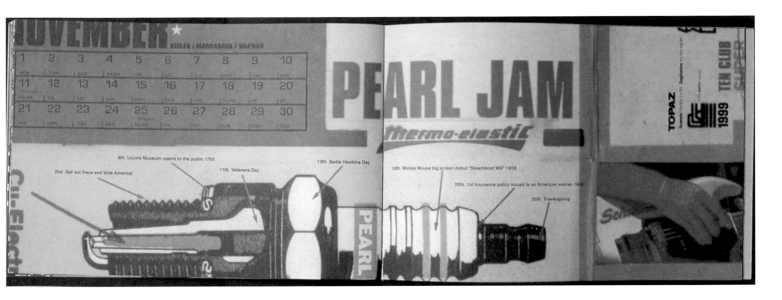

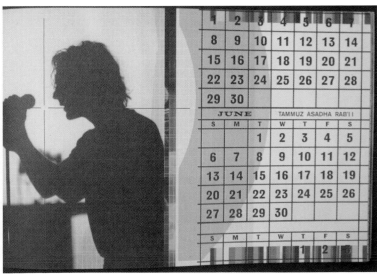

Studio: *Ames Design*
Art direction: *Ames Design*
Design: *Barry Ament, Coby Schultz, George Estrada, and Mark Atherton*
Photography: *Various*
Client: *Pearl Jam*
Year: *1999*

jeff KLEINSMITH

Hailing from Eugene, Oregon, JEFF KLEINSMITH moved to Seattle in 1990 to accept the coveted counter help position at the now infamous Zebra Copy. In 1992, he cofounded what is currently BLT Screen Printing with Brian Taylor. He also worked at *Rocket Magazine* from 1990 to 1994 (serving as art director in 1993), has served as Sub Pop Records' art director for almost nine years, and currently co-owns New Rage Records—all the while making hundreds and hundreds of posters for as many bands. In 2000, he formed Patent Pending, a design company comprised of Kleinsmith, Jesse LeDoux, and Brian Taylor. His work has appeared in numerous design magazines and gallery shows.

Afghan Whigs show poster

I had cut my hand earlier in the day with an X-acto knife and had applied a bandage to stop the bleeding. Later, while I was walking to the photocopier with resource materials intended as inspiration for this show poster, I looked down at my hand and it hit me: Make my Band-Aid into a big poster! I took the bandage off and enlarged it to poster size on the photocopier. I designed a piece of type to fit within the confines of the bloodstain and shot two transparencies (one for each color), then sent the film positives off for screen printing. The whole thing was done with a photocopier, X-acto knife, layout board, waxer, and stat camera.

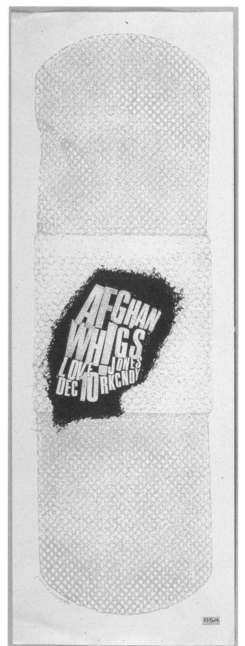

Art direction/Design: *Jeff Kleinsmith*
Client: *RockCandy*
Year: *1993*

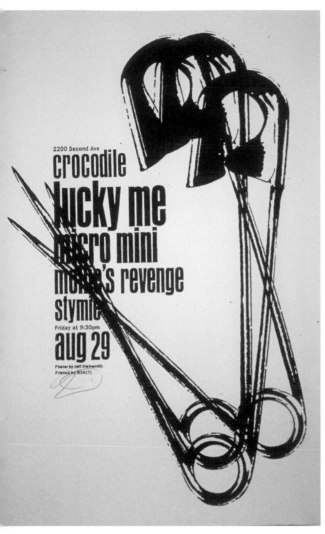

Lucky Me show poster

I was in a one-color poster stage at the time this was produced. A few years earlier I had used a safety pin in a poster for a band called Poison Idea, but as a functional element rather than as a strong central image. This time I wanted to play with the pin's form by using it in a nonfunctional way. I created type using photocopied fonts from my Dover type books and set it up for screen printing by hand.

Art direction/Design: *Jeff Kleinsmith*
Client: *The Crocodile*
Year: *1997*

Nine Inch Nails
show poster

When Grant Alden, my former editor at *Rocket Magazine*, left the publication, he started a poster/art gallery. He commissioned me to do this poster for an upcoming Nine Inch Nails concert, using sheets of metal he had found somewhere. I wanted a simple design that wouldn't take away from the impact of the metal, so I just did a basic "NIN," set up for screen printing by hand. I had just done some work for a welder friend of mine, and in return she welded this ten-inch nail to the sheet.

Art direction/Design: *Jeff Kleinsmith*
Client: *Moore Theatre*
Year: *1994*

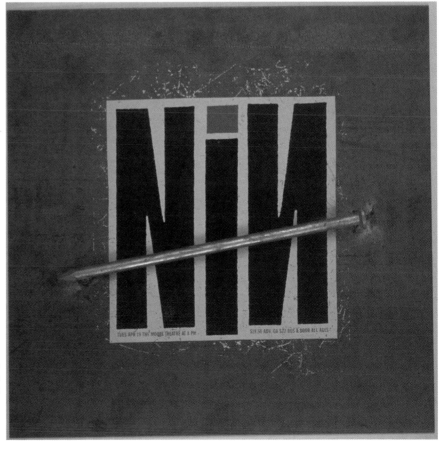

The Posies show poster

The Posies are a straightforward pop band influenced by pop-music greats from the past. When I came across this image of eyeglasses, its simplicity seemed to sum up the band as well as to suggest Elvis Costello, one of their influences. I enlarged the image to poster size on the photocopier, then created type using photocopied fonts from my Dover type books.

Art direction/Design: *Jeff Kleinsmith*
Client: *RockCandy*
Year: *1994*

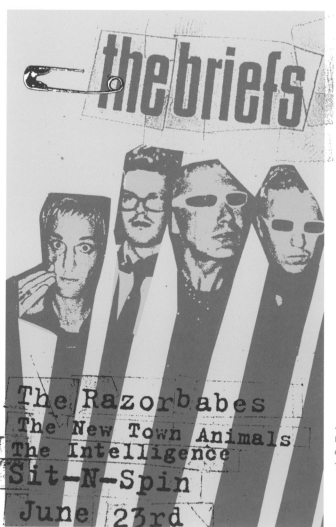

The Briefs show poster

This was art the band had created on the road and then sent it to me for use on a 7-inch single for Sub Pop Records. I had the art screen-printed, and it turned out so well that the band asked me to make it into a show poster. I created a new piece of type for the poster using a safety pin, which was not only a graphic element but also a functional way of "affixing" the type to the poster. I created type using photocopied fonts from my Dover type books and set it up for screen printing by hand with photocopier, X-acto, layout board, waxer, computer, and stat camera.

Art direction: *The Briefs*
Design: *Jeff Kleinsmith and the Briefs*
Client: *The Briefs*
Year: *2000*

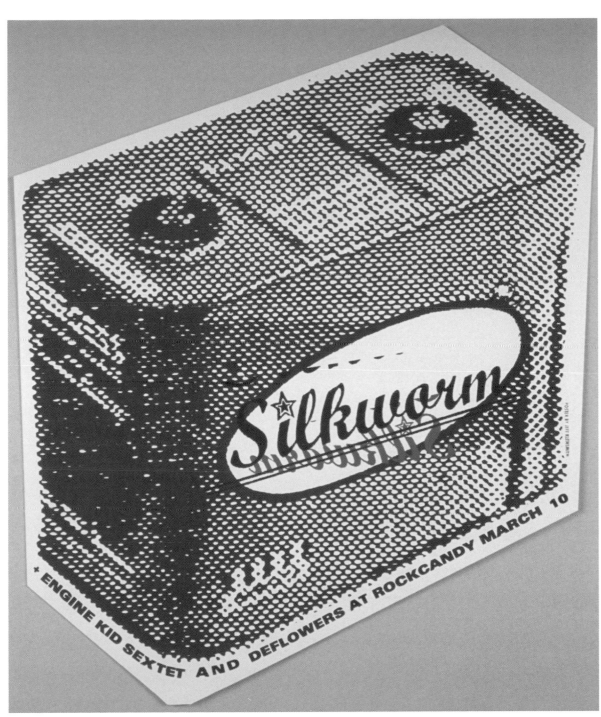

Art direction/Design: *Jeff Kleinsmith*
Client: *RockCandy*
Year: *1993*

Silkworm Battery

This poster, made for the RockCandy music club in Seattle, is another example of giving a common, everyday object new context. I found the image of the battery in the back of a 1958 *Popular Mechanics* magazine and enlarged it to poster size on a photocopier. The type was created on the computer; I made transparencies of it in duplicate and simply overlaid them in separate colors over the battery image. I set the design up for screen printing by hand. Once it was printed, I hand-cut the posters into the shape of a battery.

ZINZELL is a design-driven studio based in downtown New York City. Founded in 1995 by Don Zinzell, it offers an extended creative approach to art direction and graphic design services. The studio's signature style is based on Don Zinzell's hands-on approach: He creates most of the artwork produced by the studio. His type designs, illustrations, and photography transmit the vernacular of modern culture.

The studio's portfolio emphasizes metaphors, negative space, and reverse logic. Keeping the surface simple, Zinzell weaves multiple layers of meaning through text, images, and composition. With projects that have encompassed a broad spectrum of industries, the studio's primary interest is the intrinsic value of design and its ability to make a real difference. Services include creative consulting, logos, identities, packaging, advertising, book design, editorial design, retail graphics, and environments.

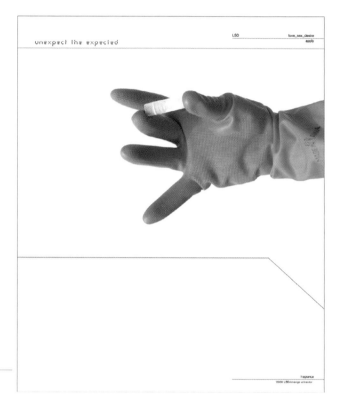

love-sex-desire ad

This is half of a double-spread advertisement for a fragrance called l.s.d., initially created for the Belgian magazine *Addict*. We decided to position the product as a science experiment, stressing that it had been created in a laboratory and was experimental. I also wanted to create an "anti-brand" that went against the typical "happy-go-lucky" lifestyle.

We used an orange rubber glove (from our studio's cleaning closet) and a warning label from the back of a Dutch excavation truck found on the street, the latter to add an element of danger and to emphasize the experimental angle. We took it one last step by adding an entire warning page (dry humor influenced by advertisements for pharmaceutical drugs). The two main images were photographed and the box verbiage scanned in from the actual item (which had been found on the street). I wore the glove on one hand and photographed it with the other—and yes, that makes me a hand model. The glove is still used for cleaning.

Studio: *Zinzell*
Art direction/Design: *Don Zinzell*
Photography: *Don Zinzell*
Client: *Strange Attractor/l.s.d*
Year: *2000*

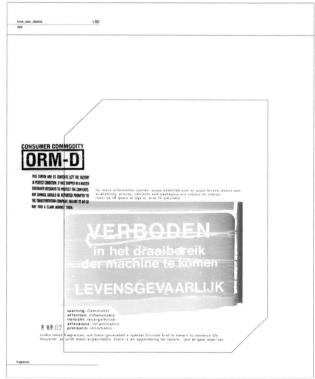

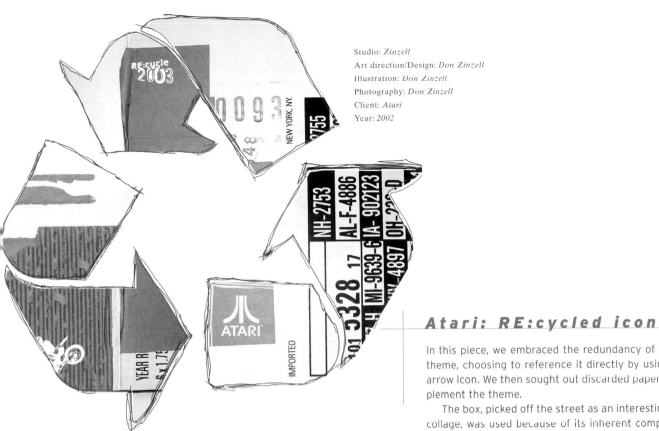

Studio: *Zinzell*
Art direction/Design: *Don Zinzell*
Illustration: *Don Zinzell*
Photography: *Don Zinzell*
Client: *Atari*
Year: *2002*

Atari: RE:cycled icon

In this piece, we embraced the redundancy of the "RE:cycle" theme, choosing to reference it directly by using the circular arrow icon. We then sought out discarded paper items to complement the theme.

The box, picked off the street as an interesting ready-made collage, was used because of its inherent composition. I photographed it at different angles and chose three, one for each arrow. After scanning the photos, the image was shaped and manipulated digitally, and the white illustration, type treatment, logo, and pen drawing were added. All of the artwork came from our studio except for the logo, which was supplied by Atari.

Atari: RE:cycled

Opting for a low-tech approach to a high-tech company, we came from the position that Atari can be irreverent yet still responsible. Using a crushed egg carton and oversized logo as metaphors, we conveyed the power and fragility of virtual life in a video game. The "RE:cycle" theme addresses the environment (motocross) as well as Atari's return to the marketplace. We used the motorcycle icon as a general representation of extreme sports.

It just so happened that the first paper-pulp egg carton we pulled from the trash bin was perfect in form, color, material, and texture. I stomped on it to create the subtle attributes we were looking for, then photographed it and featured it as a pure image.

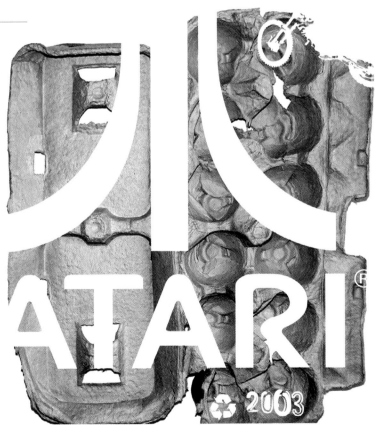

Studio: *Zinzell*
Art direction/Design: *Don Zinzell*
Ilustration: *Don Zinzell*
Photography: *Don Zinzell*
Client: *Atari*
Year: *2002*

Container

The design of this font (Container) was influenced by, well, containers. Shown here are only a few of the items that were photographed; we collected all types of dot matrix samples and they appear in various promotional print pieces.

The font was first designed on a grid; I then drew a clean version in Illustrator. After the work was imported into Fontographer, I created additional versions of the font and generated various widths.

Studio: *Zinzell*
Art direction/Design: *Don Zinzell*
Photography: *Don Zinzell*
Client: *Zinzell*
Year: *2001*

Studio: *Zinzell*
Art direction/Design: *Don Zinzell*
Photography: *Don Zinzell*
Illustration: *Don Zinzell*
Client: *Standard Architects*
Year: *2002*

STANDARD
ARCHITECTS

www.standardarchitects.com

97 N. 10th Street
B'klyn, NY 11211
ph 718 486 0301
fx 718 486 0831

Standard Assemblage

This promotional piece for an architectural firm focuses on the company's outside-of-the-box utilitarian thinking. This firm often works with unusual natural materials to create spaces that are high-end, minimalist, and intelligent. It also emphasizes detail, craftsmanship, and creative design solutions. We decided to convey this with a design that was raw and deconstructed. I also wanted to translate a three-dimensional company into two dimensions.

After a week of surveying deconstructable three-dimensional items, my favorite turned out to be this Kleenex box. I photographed the interior of the flattened box, keeping it true to its material, texture, and scars. This was then juxtaposed with industrial icons that we illustrated: chainsaw, rotor-saw blade, and die strike.

Studio: *Zinzell*
Art direction/Design: *Don Zinzell*
Photography: *Don Zinzell*
Client: *Lincoln Mayne*
Year: *2002*

Mayne

This promotional piece for a clothing store was based on a rare find: dental molds, which had been discarded by a dentist and found on the street by a friend of the clients. When I initially went to the store to discuss the project, the molds were sitting in a corner and immediately caught my eye; it didn't take long for us to decide to incorporate them into the project. The molds add instant street credibility and "personality" to the store's image.

We photographed about ten sets of molds before selecting these three for their atypical features. The others are sure to surface in another project.

lincoln mayne™
123 ludlow st nyc
fabricator of fashion + fine art
mobile: 1-917-554-4478

STEPHEN FARRELL is principal and founder of Slipstudios, a venue established in 1992 to facilitate the research, writing, design, and production of collaborative literature and visual essays, digital typography, and ambient music. Farrell's projects—short stories, novellas, essays, performance readings, and interactive digital works—have garnered numerous awards, including two nominations for a Pushcart Prize, a National Design Award nomination in Communications from the Smithsonian Institution, and the Tsujinaka Experimental Fiction Award of Kyoto. Farrell's first full-length image-text novel, *VAS: An Opera in Flatland*, a collaboration with writer Steve Tomasula, explores biotechnology's strategies for representing the corporeal body. Farrell is assistant professor of design and typography at the School of the Art Institute of Chicago. He graduated from Ohio State University in Columbus, Ohio.

Visible Citizens

This piece—part essay, part performance—explores lineage and connoisseurship through tangents between strokes made with a catalog of abandoned brooms and speaking/writing exercises from nineteenth-century courtesy books and shorthand manuals. A blend of cultural anthropology, philosophy, literature, and linguistics, it plays with our impulses to classify and to express civility.

All of the brooms and courtesy books were discovered in an eighty-year-old house recently purchased by my wife, Jiwon, and I. During the first, massive house-cleaning, we practiced with each broom, testing its shape and willingness to move dirt. For the sweeping gestures in the essay, we set out large panels of white Masonite and sprinkled squares of graphite and cloves (a mixture we determined as most archetypally "dirt-like" after several attempts with other concoctions). I used each broom to sweep a single stroke, which we photographed, followed by enough strokes to "clear the square," which we also photographed. Brooms and book pages were photographed, along with a catalog of temperature gauges. We then played with photocopies of these images to pair pen strokes with broom strokes and to determine general layouts (which reference natural history exhibits and the display of field samples). Jiwon illustrated systems of hooks throughout the house. Scans of the photos were manipulated in Photoshop, using duotone functions for some of the images and translating others into coarse, dithered bitmaps to accentuate the texture of dirt. The piece was assembled in QuarkXpress.

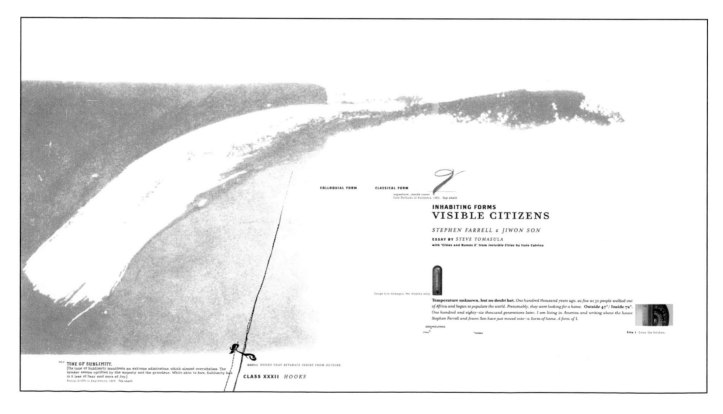

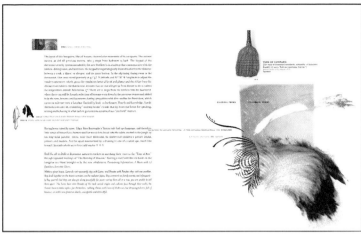

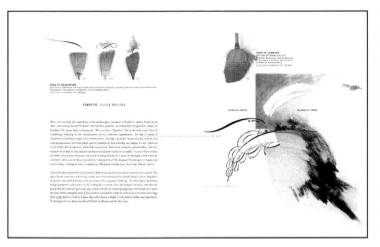

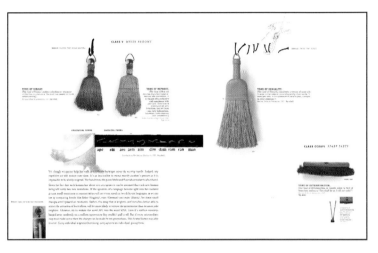

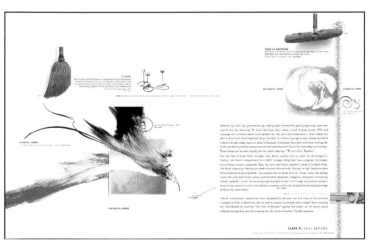

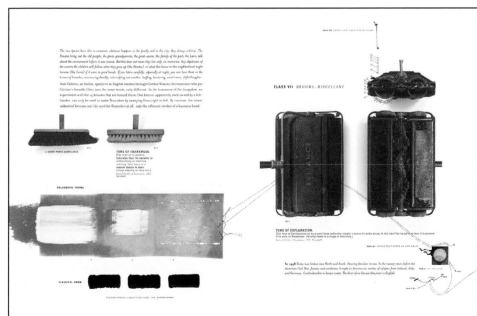

Studio: *Slipstudios*
Art direction: *Stephen Farrell*
Design/Illustration: *Stephen Farrell and Jiwon Son*
Photography: *Stephen Farrell*
Text: *Steve Tomasula, Stephen Farrell, Italo Calvino (Invisible Cities), and Arthur Edward Phillips (Natural Drills of Expression)*
Client: *Emigre Magazine*
Year: *1999*

The Gregg Bendian Project

Poet Brooke Bergan spontaneously generates texts while watching performances of music or dance. For her review of a percussion-based jazz trio called the Gregg Bendian Project, I reacted with a performative visual treatment to counterpoint the rhythmic cadences running through her text.

I generated all images by staging a broken Slinky and a silk scarf on a flatbed scanner—no photography was used. Playing with these two elements elicited some very expressive scenes, which were cropped or layered in Photoshop. These Photoshop images provided a base atmosphere for a fairly linear type treatment in Illustrator. Flat shapes and more expressive typography emphasize certain parts of the poem and certain movements in the background scenes.

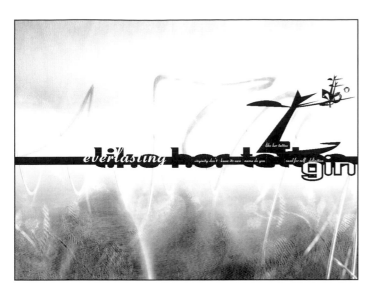

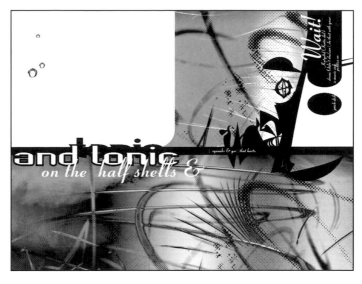

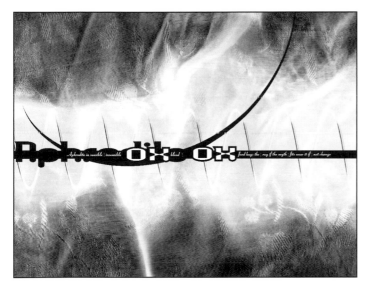

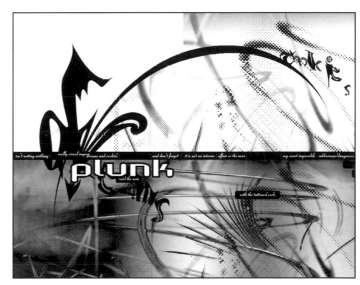

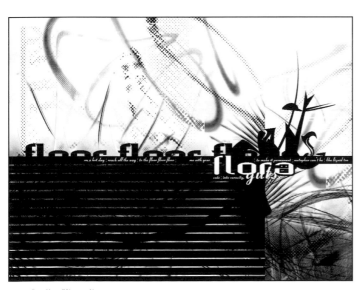

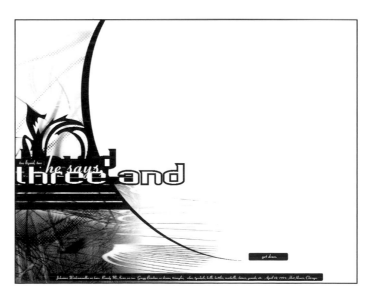

Studio: *Slipstudios*

Art direction/Design: *Stephen Farrell*

Illustration: *Stephen Farrell*

Text: *Brooke Bergan*

Client: *Private Arts literary journal*

Year: *1993*

mariaGAVIRIA

Born in Bogota, Colombia, MARIA GAVIRIA studied graphic design at a Colombian design center called Taller 5, and in Los Angeles at Otis College of Art and Design. After one year of non-degree classes at Otis, however, Gaviria ran into financial problems and was forced to return to Colombia. In 1999, after seven years of working for a Colombian advertising agency (Procesos Creativos Euro RSCG) and having won the Colcultura National Award for logo design, she was able to return to the United States, where she earned a B.F.A. in graphic design from the Art Center College of Design in Pasadena, and later freelanced at the Art Center Design office and at Chase Design Group. In 2002 she became a full-time designer at Chase Design Group.

Hair

The client for this piece was a hair stylist who wanted a business card with only the word "hair" on it. She wanted the word to be as big as possible, and the card to be as simple as possible—she didn't even want her last name on it. Although I knew a simple font would work, I wanted to give the card identity, to make it stand out from the rest. So I made the word "hair" out of my own hair.

I collected hair for a few days. I cut it, twisted it, knotted it, trying to get the right shapes. I scanned the most successful letterforms, as well as some pieces of hair that I manipulated in Photoshop to create the remaining letters. The scans were done in black and white, but when designing the card I felt it needed some color, so I changed the color of the hair.

Art direction/Design: *Maria Gaviria*
Client: *Marian Hackman*
Year *2001*

Frida's Corset

This is a piece I made for school. I was given a plastic bag and asked to choose someone I admired. I chose Frida Kahlo. I was to then make an object that represented this person and place it inside the bag. I chose to make a corset. Frida was a woman trapped by physical suffering following an accident she'd had as a young woman, as well as by her love for Diego Rivera. She spent years of her life bed-ridden and had to wear painful corsets, which she often painted. Her life was in many ways miserable, yet she seemed to also enjoy talking and painting about her pain, as if it was her protection and her way of manipulating others.

In the beginning I considered using plaster, but I wanted to use materials that I had at home, and happened upon a great piece of chicken wire that a neighbor had left in the yard. I shaped a corset out of the wire, which turned out to be much easier and cleaner to work with than plaster. I also loved the fact that the corset would remain sturdy but empty inside—strong but fragile, just like Frida. I covered the wire with Japanese paper printed with a collage I'd made of Frida's work and writing, and textures I'd put together in Photoshop. I nailed it to symbolize her lifetime of physical pain. The corset was placed inside the bag, on which I printed text from Frida's diary (in her own handwriting), thus reinforcing the idea that she was trapped not only by her health but also by herself.

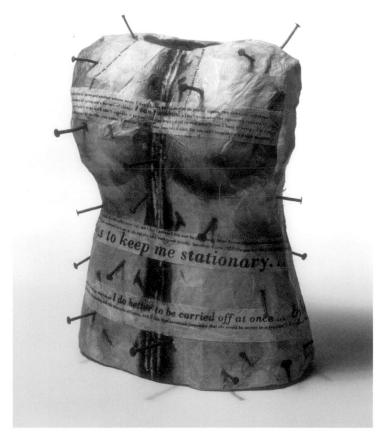

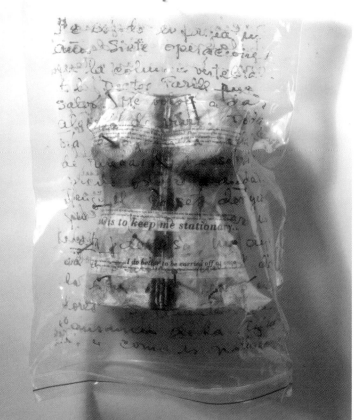

Class: *Typography 2, Art Center College of Design*
Teacher: *Susana Mendive*
Design: *Maria Gaviria*
Illustration: *Maria Gaviria*
Photography: *Jason Ware*
Year: *2000*

Alien

This is a motion piece I created for school. The assignment was to make a word out of something and then shoot it, trying to re-create its meaning. The word I chose was "alien," which I formed out of bones. I then made a set out of a water-filled bowl and a blue background. I started shooting the little bones with a video camera while moving them inside plastic bags, thus creating an abstract environment in which the letters swam like individual creatures in a poetic world. The fact that I chose something as familiar and organic as bones to re-create the word "alien" made its organic quality so foreign that the bones turned into something else, into something alien.

Class: *Dynamic Type, Art Center College of Design*
Teacher: *Micah Hann*
Design: *Maria Gaviria*
Camera: *Maria Gaviria*
Year: *2001*

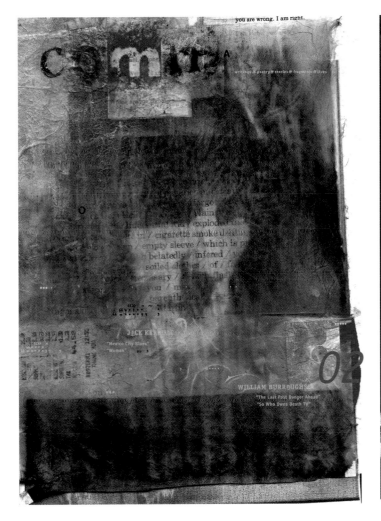

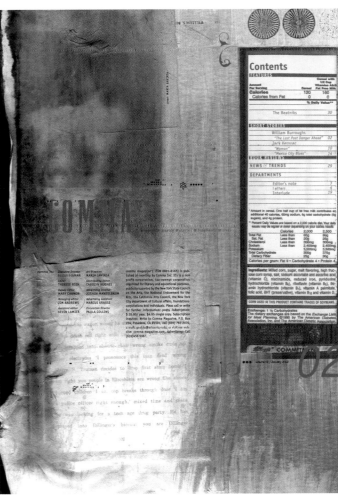

Class: *Independent study, Art Center College of Design*
Design: *Maria Gaviria*
Year: *2001*

Comma

Comma is a literature magazine I made up for an independent study assignment. I chose to create a literary magazine because I wanted to work with texts, to focus on type and its expressive qualities. The magazine's header and cover always change and for the second issue the Beatniks were the chosen topic. Using collage with everyday objects made perfect sense for the subject.

I decided to work with the stuff that I had around: copies of William Burroughs' work from my research, his writings, old receipts, old paper. The inspiration for using a nutritional contents chart for the table of contents came to me while having breakfast, looking at my cereal box. I liked the metaphor of a literature magazine as something that nurtures you; I also liked the interesting relationship created by leaving some of the original nutritional contents untouched, joined by new lines listing the contents of the magazine.

GROUNDZERO is a New York–based design studio that helps clients express their unique visions via traditional and interactive media. The firm was founded in 1990 by Craig Winkelman and Jane Ryan Beck, who continue to act as principals and creative directors.

For more than ten years, groundzero has provided design solutions to a diverse group of clients, ranging from Fortune 500 companies such as ABC/Walt Disney and Merrill Lynch, to nonprofit organizations such as the Center for Reproductive Rights and the Breast Cancer Research Foundation.

Groundzero has produced magazines, book covers, identity programs, signage systems, films, Web sites, and interactive multimedia. The studio's creative staff brings decades of experience to a cross-disciplinary practice, delivering innovative and effective design solutions for an intimate client base.

MERZ 111090

MERZ is a reanimation of an idea long since forgotten. Invented by German artist Kurt Schwitters in 1919, "merz" was a term used to describe a wide variety of artistic output. Schwitters's work used a dizzying array of materials—everything from locks of a friend's hair to trash found on the street. As Schwitters explained in the magazine *Der Sturm* in 1919:

> The word *merz* denotes essentially the combination, for artistic purposes, of all conceivable materials, and technically, the principle of the equal evaluation of the individual materials. Aperambuator wheel, wire-netting, string, and cotton wool, are factors having equal rights with paint.

Groundzero resurrected the merz concept to celebrate the world around us today, welcoming collaborators from outside the insular artist community. Contributors, drawn from friends, colleagues, and friends of colleagues, were asked to return a 7-inch square sheet of cardboard, decorated with art inspired by a found object. Among the participants were scientists, filmmakers, chefs, musicians, photographers, painters, and philosophers. Twenty-four submissions were returned, including collages, short stories, recipes, paintings, drawings, and reclaimed garbage.

The submissions—all hand-produced and assembled—were then bound with three 1/4-inch steel nuts and bolts to form a book. The cover art was spray-painted on through a hand-cut stencil. The interior typography was set in SaraFont, a digital typeface created at groundzero and based on the handwriting of the designer's nine-year-old niece, Sara.

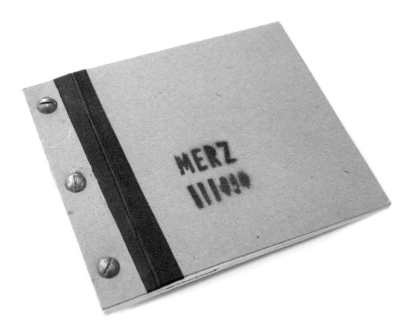

Studio: *groundzero*
Art direction: *Craig Winkelman and Jane Ryan Beck*
Design: *Craig Winkelman*
Illustration: *Various*
Photography: *Various*
Client: *Independent project*
Year: *1990*

After leaving Albert Street, Parise moved to the Lincoln-Knolls Plaza where he opened an arts and crafts store with a lunch counter. Harrassment and hold-ups forced them to leave the Plaza.

Women with outside of house wallpapered.
Submitted by Mark Peyko, designer.

Pig recipe.
Submitted by Diana Stoll, chef/writer.

Mouse/lead contamination.
Submitted by Joe Rojas-Burke, science writer.

Coffee cup collection.
Submitted by Craig Winkelman, designer.

STEFAN SAGMEISTER, a native of Austria, received an M.F.A. in graphic design from the University of Applied Arts in Vienna and, as a Fulbright Scholar, a second M.F.A. from Pratt Institute in New York. In 1993 he formed the New York–based Sagmeister Inc., and has since designed graphics and packaging for the Rolling Stones, David Byrne, Lou Reed, Aerosmith, and Pat Metheny. His work has been nominated four times for a Grammy Award and has won most international design awards. In 2001 a monograph about his work, *Sagmeister, Made You Look*, was published by Booth-Clibborn editions.

stefan
SAGMEISTER

Copy spreads

Each month, *Austrian Magazine* commissions a different design firm to create six double-page spreads. The spreads serve as dividers in the magazine, each introducing a new "chapter." The designers are given almost complete freedom, the only mandate being that the six spreads must share an overlying design concept. Our spreads, when joined together, read: "Everything/I do/always/comes/back/to me."

We started with the backgrounds, finding them at clothing wholesalers and the wallpaper company Wolf-Gordon, which is also one of our clients. We then sought out various objects for making the type–at the butcher's, in Chinatown, in grocery and hardware stores. These objects ranged from whitefish to dead plants found on my roof, hair from a discarded Halloween wig, and rubber tubing from a medical supply store.

Our intern, Eva Hueckmann, created most of the lettering by manually manipulating the objects. We then photographed the letters, scanned them, and refined the scans in Photoshop and Illustrator, adding things like diamonds and little plastic horses, the latter found lying around from a previous fashion design job.

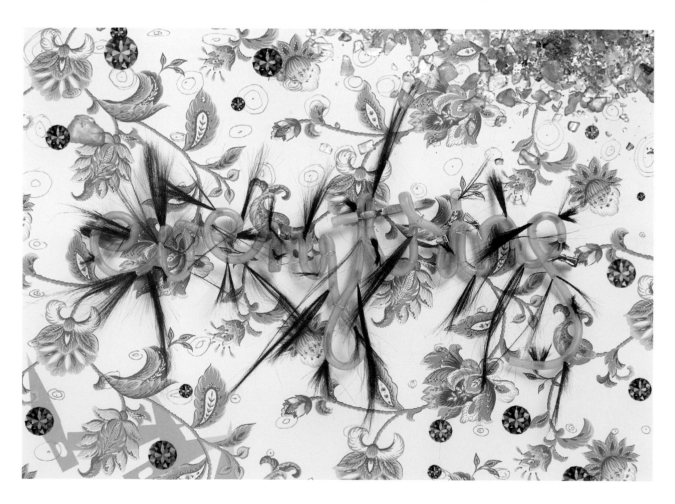

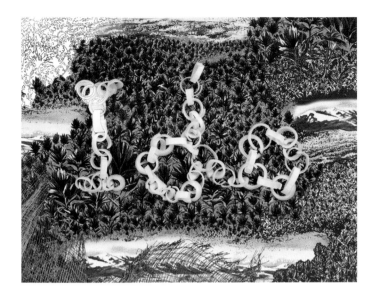

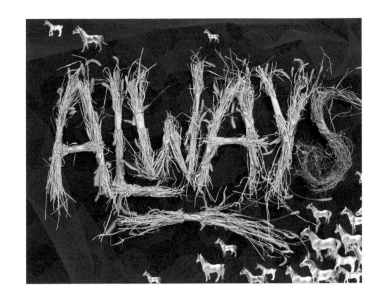

Studio: *Sagmeister, Inc.*
Art direction: *Stefan Sagmeister*
Design: *Eva Hueckmann, Matthias Ernstberger,*
Doris Pesendorfer, and Stefan Sagmeister
Photography: *Matthias Ernstberger*
Backgrounds (for the spreads "everything" and "to me"): *Wolf-Gordon, Inc.*
Client: *Austrian Magazine*
Year: *2002*

David Byrne book

David Byrne came to us with two boxes of his artwork, to put into book form. The resulting book, which measures 11 by 14 inches, is titled *Your Action World: Winners Are Losers with a New Attitude*. Half of the title type is embossed into the vinyl cover, the other half printed on a shopping bag; the two must be viewed together to form the complete title.

The basic focus of Byrne's book is the domination of 1990s America by a mixture of big business and the self-improvement movement. One chapter, for example, focuses on corporate signage; another explores the various types of observation cameras that film us as we go about our daily lives. All of the images were "found" (photographed) by Byrne on his travels.

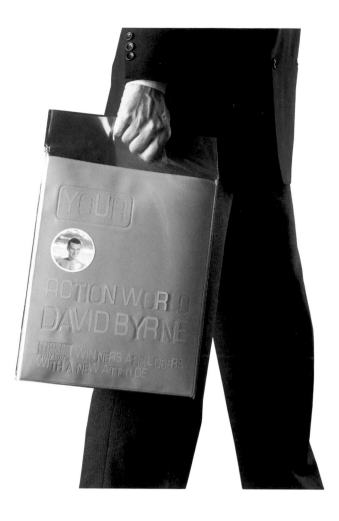

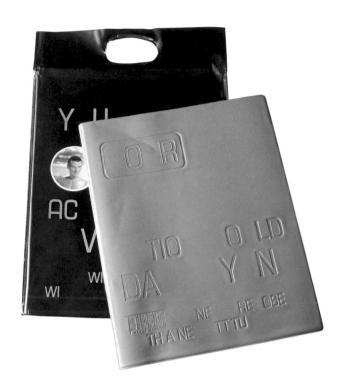

You are accosted in a dark alley by 3 armed youths who demand your wallet, but you are, unbeknown to them, carrying a powerful semi-automatic weapon.

Do you:
A. ☐ Administer justice. Shoot first and ask questions later, it's self defense.
B. ☐ Pull your weapon but leave the scene peacefully.
C. ☐ Give up your wallet and avoid the risk of violent confrontation.

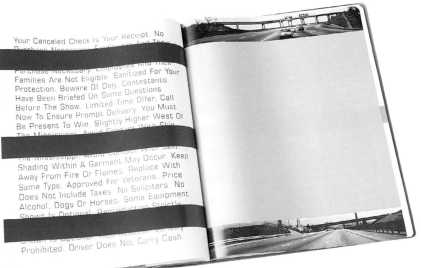

Your Canceled Check Is Your Receipt. No Purchase Necessary. Employees And Their Families Are Not Eligible. Sanitized For Your Protection. Beware Of Dog. Contestants Have Been Briefed On Some Questions Before The Show. Limited Time Offer. Call Now To Ensure Prompt Delivery. You Must Be Present To Win. Slightly Higher West Of The Mississippi. Avoid Contact With Skin. Shading Within A Garment May Occur. Keep Away From Fire Or Flames. Replace With Same Type. Approved For Veterans. Price Does Not Include Taxes. No Solicitors. No Alcohol, Dogs Or Horses. Some Equipment Shown Is Optional. Reproduction Strictly Prohibited. Driver Does Not Carry Cash.

Studio: *Sagmeister, Inc.*
Art direction: *Stefan Sagmeister and David Byrne*
Design: *Stefan Sagmeister and Hjalti Karlsson*
Photography: *David Byrne*
Client: *Gotham (Milan, Italy)*
Year: *1998*

FIREHOUSE101art&design

FIREHOUSE 101 ART & DESIGN, a full-service design studio specializing in logo identity, on-air graphics, print, and multimedia, was formed in 1990 by Kirk Richard Smith in Columbus, Ohio. The company name is a metaphor for a house of emotion (fire). The original idea was to create a design studio that incorporated passion, spontaneity, and intuition into the communication process. Firehouse incorporates these elements—often seen as traits of the fine arts world—as necessary layers of communication to evoke emotion and personality to and from a subject. Clients include Sony Music, Arista Records, MTV Latino, HBO, Nickelodeon, Columbia House Records, Levi Strauss & Co., Word Music, Locomotion Channel, Harcourt Brace, Structure, Express, Limited Too, *Raygun*, *HOW*, and others.

Ted Rice postcards

This series of promotional postcards highlights the work of photographer Ted Rice. The alternating areas of texture were intended to accentuate the photographs' colors and add subliminal levels of meaning through their typography and/or graphics. Each postcard was mailed in a transparent vellum envelope.

The textures were created by cutting up Hollywood glamour magazines of the 1940s, men's magazines of the 1950s, photography advertisements of the 1960s, and an old Bible from the 1890s. Each word was hand glued onto cardboard to form a collage, then the collage was scanned as a complete image.

Studio: *Firehouse 101 Art & Design*
Art direction/Design: *Kirk Richard Smith*
Collage: *Jamie Sherman and Kirk Richard Smith*
Photography: *Ted Rice*
Client: *Ted Rice Photography*
Year: *1996*

Studio: *Firehouse 101 Art & Design*
Art direction/Design: *Kirk Richard Smith, Marcelle Gilkerson, and Scott Summers*
Photography: *John Weber, Stephen Webster, Will Shively, and Michael Cogar*
Folk sculpture: *David Butler*
Digital retouching: *Keith Novicki*
Client: *RPA*
Year: *1996*

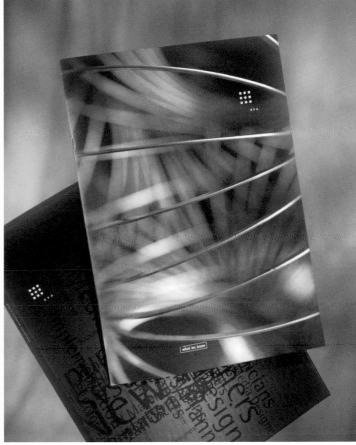

RPA (Retail Planning Associates) corporate capabilities brochure

The concept was to design a corporate capabilities brochure that not only included a printed portfolio of the client's projects, but also described the personality of the company and its problem-solving methodology. The main corporate capabilities piece was broken into a four-step process: Introduction/Overview, How We Think, How We Do It, and Global Communications and Marketing, each paired with an image that metaphorically defined that step in the process. Artists were chosen to interpret an area based on their particular talents and how they lent themselves to defining the personality of the client.

The main images included the following:

• Cover of the brochure: a photograph of a Slinky, which was enhanced in Photoshop to create an ambiguous image of movement and connectivity.

• Introduction/Overview: a photographic collage by John Weber that focused on the retail fashion industry (RPA's clientele), incorporating found metal, a wooden door, a zipper, and menus.

• How We Think: an image by Stephen Webster of a winged phrenology head, which was a metaphor for visionary thinking.

• How We Do It: a collage of gears by Will Shively, which conveyed the movement and process of an idea. The gear elements came from a collection of found metal objects in his studio.

• Global Communications and Marketing: folk artist David Butler's mixed media sculpture, which included found toys, bingo cards, springs, bottle caps, and wooden boxes to illustrate a collective message of global communications and marketing.

ProMusica poster

This poster was made to celebrate the 2001 season of ProMusica, an award-winning chamber orchestra that presents classical favorites as well as works by contemporary composers. The image depicts a winged messenger of the spirit of music, who has the ability to pull love from the hearts of listeners.

The painting was created as a collage of found papers. Colorful fabric textures were cut from 1950s fashion magazines; a handwritten letter from the 1890s was also incorporated. Sheet music from the 1940s was used for texture. The main image was transferred onto a canvas with acrylic paint used to finish.

Studio: *Firehouse 101 Art & Design*
Art direction: *Kirk Richard Smith*
Design: *Moorhead Design*
Illustration: *Kirk Richard Smith*
Client: *ProMusica*
Year: *2001*

Firehouse 101 Art & Design advertisement

The concept for this advertisement was to create a dynamic presence directed at entertainment clientele. The ad appeared in *The Alternative Pick* publication.

There are many found objects within this particular piece. I used a picture of my father as a child, riding a rocking horse. He had passed away around this time period, and I liked the image because it seemed as if he was on a journey with the horse. We also used images of erotic dancers and advertising images from 1950s men's magazines. A letter from a baby's journal and my wife's kindergarten report card were used as copy, the latter because I liked the directness of the statements of achievement (for example, "I use complete sentences."). A found photograph of a child from the early 1900s was incorporated for a dream-like effect. A picture of my grandmother was used within a cross shape as a tribute to her. Hair was scanned for texture. Photographs were taken of a Barbie doll and altered.

Studio: *Firehouse 101 Art & Design*
Art direction/Design: *Kirk Richard Smith*
Painting: *Kirk Richard Smith*
Photography: *Will Shively*
Client: *Firehouse 101 Art & Design*
Year: *1995*

Studio: *Firehouse 101 Art & Design*
Art direction/Design: *Kirk Richard Smith*
Illustration: *Kirk Richard Smith*
Photography: *Unknown*
Client: *Byrum Printing*
Year: *1997*

Byrum poster

The client, Byrum Printing, commissioned a different artist or design studio each month to create a calendar page that conveyed techniques and attitudes associated with the printing process. These pages were then used as monthly promotional tools for the Byrum sales team. The month we designed was August.

The images we chose included a photograph of a female model from the 1950s (bought at Union Square in New York City for five dollars), a piece of type about phobias from a 1950s men's magazine, and a woman's fake eyelash, which was placed on the scanner. The final poster design was printed as a four-color process with silver as a fifth color.

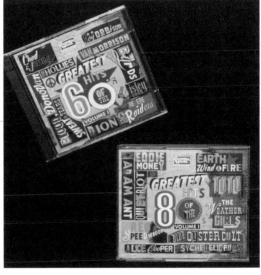

Columbia House Records Greatest Hits Series CD covers

The concept was to make covers for a series of CDs highlighting the greatest hits of the 1960s and '80s. We were to utilize some stereotypical elements and attitudes of the eras but also introduce an artistic, handcrafted, eclectic element. The CDs were given out as membership incentives.

Both CD covers incorporate found typography, which was collaged together to make the final compositions. The wood used as the base texture came from a dynamite box found in a flea market; the typography came from fruit labels, also bought at flea markets. Letters were cut from the labels, glued to a piece of cardboard, and scanned into Photoshop, some then resized to accommodate the composition. The overall intention was to achieve an eclectic mix of styles and attitudes amongst the typography while still incorporating graphics related to the 1960s and '80s.

Studio: *Firehouse 101 Art & Design*
Art direction: *Chris Thompson and Kirk Richard Smith*
Design: *Martha Dwyer and Kirk Richard Smith*
Illustration: *Kirk Richard Smith*
Client: *Columbia Records*
Year: *2002*

Movies that Rock! poster

The concept was to make a poster that celebrated the "Movies that Rock!" celebration party for the Young Professional Board of Ronald McDonald House Charities. The party was held at a local nightclub and featured music and clips from several seminal movies. The project was done on a pro bono basis, with proceeds benefiting Ronald McDonald House Charities.

The main Photoshop collage incorporated photographs of a piece of projector film and of a microphone bought at Jimmy Ray's audio equipment (circa 1950s). We wanted to communicate "rock'n'roll" and "film" in an immediate manner, so we went with obvious symbols for both. Once collaged together in Photoshop, we gave the image a more modern feel through color enhancement and transparency layering.

Studio: *Firehouse 101 Art & Design*
Art direction: *Kirk Richard Smith*
Design: *Kirk Richard Smith and Amanda Menge*
Illustration: *Brad Egnor (Egnor Design)*
Photography: *Stephen Webster*
Client: *Young Professional Board, Ronald McDonald House Charities*
Year: *2001*

michaelGARSON

Ever since he was a child, MICHAEL GARSON has been fascinated with other people's junk, always forcing his mother to pull over at yard sales, digging through the neighbors' trash, and finding so many "perfectly good television sets" to rescue.

After graduating with a B.S. in theology, Garson moved to Philadelphia, where he studied under well-known photo illustrator Heidi Merschner. He found himself inspired by the decaying remains of the industrial revolution and began implementing this inspiration into his design.

Garson is currently working in Venice Beach, Los Angeles, as a freelance designer and illustrator. He's won several awards for his work, including first prize at Seybold Seminars 2001 San Francisco Digital Art Contest, and is a member of the Society of Illustrators, Los Angeles.

Design: *Michael Garson*
Client: *Independent project*
Year: *1999*

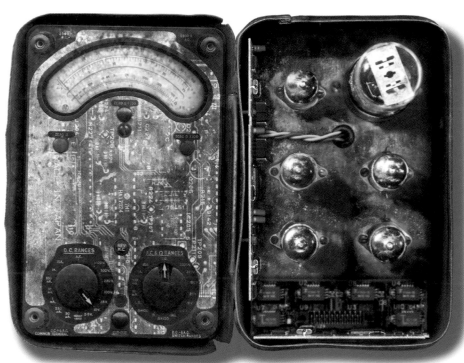

Tea Tin pieces

Tea Tin

This self-promotion piece was meant to be accompanied by *First-Aid Tin* (page 104). I wanted to combine *First-Aid Tin*'s technology of the future with *Tea Tin*'s technology of the 1930s and '40s.

I started the piece with an old rusted tea tin. I then took apart an old guitar ampli-fier and shot some photos of its vacuum tubes. In Photoshop, I layered a circuit board over an old voltmeter, visible in the left side of the design.

Psalters

This piece was created as an album cover for Burnt Toast Vinyl, an eclectic band whose influences include folk, Middle Eastern, Hebrew, and electronic music. In order to communicate the feeling of the band, I combined organic, technological, and religious elements.

I started with an image from a prayer card and a circuit board from an abandoned computer. With adjustments to the lighting in Photoshop, I made the wires appear to weave into the form of the body. Then I hand-drew the wings to give more motion to the piece. The wooden-looking element on the left is actually the edge of an old photograph.

Studio: *Garson Design*
Design: *Michael Garson*
Client: *Burnt Toast Vinyl*
Year: *2000*

First-Aid Tin

This piece was pretty much inspired by the post-apocalyptic world of the *Twelve Monkeys* film and a spy suitcase from an old Six-Million-Dollar Man toy. I wanted to create a spy device that had no clear purpose but would evoke plenty of thought as to what it might be. I made this piece for my own enjoyment, but also for self-promotion.

I started the piece by burning an old first-aid tin I'd found, then scanning it into the computer. This created the wonderful colors you see behind the cog on the right side. The cog was actually some kind of grinder from a shoe-making machine. Some of the other elements include number LEDs from a hydraulic lift and lights from an old printer. On the left side, I layered computer chips with a circuit board to create a corroded, textured look.

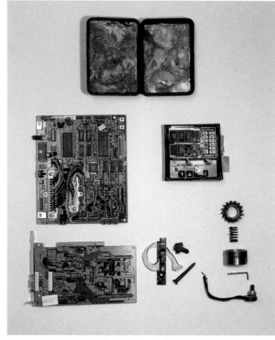

First-Aid Tin pieces

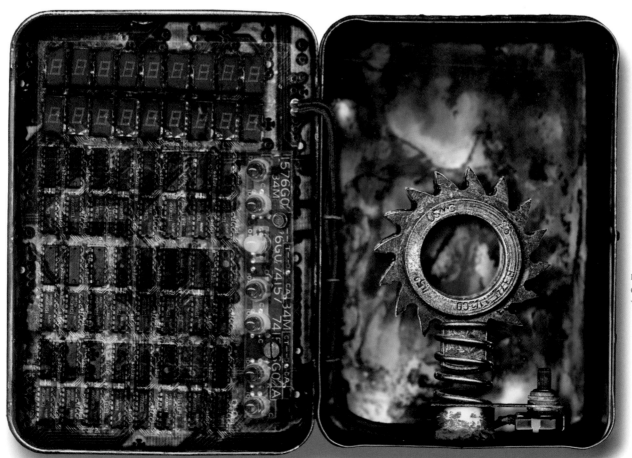

Design: *Michael Garson*
Client: *Independent project*
Year: *1999*

Bull & Bear

This was a financial piece I made for self-promotion, to test the financial design market. It is meant to show the interactions, measurements, and stresses between bull and bear markets.

First I photographed the masks of the bull and bear and a ruler I'd found. I used an old money bag for the canvas texture in the background. I then photographed a micrometer and retouched it in Photoshop so that it would fit around the bull and bear; I flopped the photo and retouched it again to make it look like two different micrometers. The time-zone clocks are actually the hands of an antique gas meter, which I applied as a hard light layer.

Design: *Michael Garson*
Client: *Independent project*
Year: 2002

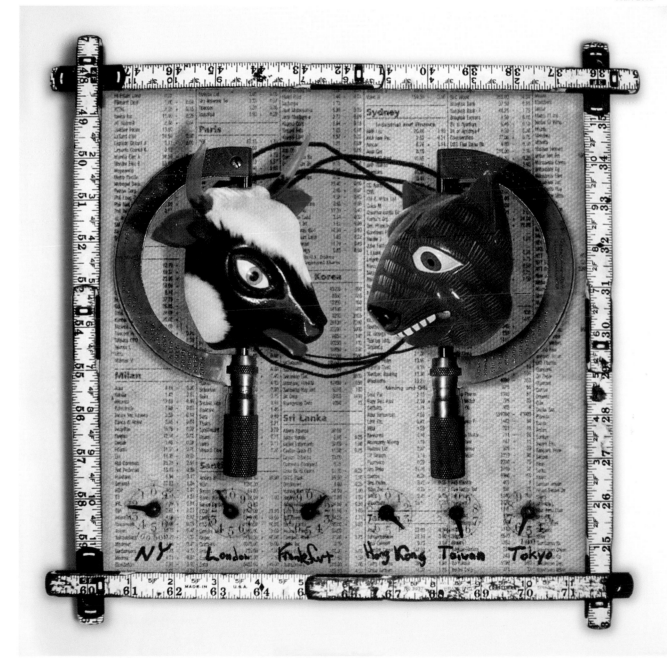

jeffJOHNSON

JEFF JOHNSON was born in rural Fargo, North Dakota. After spending his first two decades as a farm kid and heavy equipment operator on the high plains, he attended art school in Moorhead, Minnesota, a quirky art town in the middle of nowhere with museums funded by charitable blackjack and old ladies compulsively playing bingo. He graduated with honors and, living out of his 1983 Buick Skylark, began working for Duffy Design and Fallon Worldwide in June 1992. Johnson worked his way up from intern to designer, senior designer, and finally design director of a large staff. While at Duffy, he designed such pop icons as Frutopia™, Diet Coke™, and the Miller Time™ "Dick" campaign.

In 1998, Johnson cofounded Spunk, a collaborative creative studio, in his adopted hometown of Minneapolis. He has since traveled the world promoting new design techniques and models for pushing pop culture to the next level. In its short life, Spunk has manufactured and sold two educational products for kids (Talking Tools™ and Pufflines™). It has also won local, national, and international design awards for its creative solutions for clients, ranging from local gay bars to CNN Worldwide. Spunk also designs fonts, does custom product design, and often drinks a ridiculous amount of coffee.

Johnson employs a small staff at Spunk, trying to help foster the community of designers and artists in Minneapolis. His work is part of the Smithsonian Institution's permanent collection of twentieth-century American design, and he shows current work once a year at the Spunk Spring Art Show. Jeff lives with his wife in Minneapolis.

Dr. Gargantuan

Showtime

Attack of the Gymnasts

Superstar

Sticky Circus

True Love

Buckin Bronco

Runaway Monkey

Doggy Dog

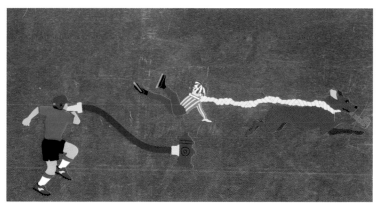
Fundraiser 2002

Sticker Stories

Like most art studios, the Spunk shop is stuffed floor-to-ceiling with art materials of long-forgotten origin or purpose. One day, we came across an aging box of stickers and fell in love. The collection of bright, colorful, playful art began taking on a life of its own: It seemed so pure and raw that we couldn't keep our hands away. Cheerleaders, school kids, religion, medicine, business, art—the whole messy range of the human condition seemed packed inside this archival collection of plastic stickers.

The stickers began showing up everywhere. Like some kind of polyester graffiti from hell, they became part of the visual air we breathed. We placed, arranged, rearranged, and experimented with the stickers, amazed with the unique narratives that each composition created. Sticker-stories began to emerge, and we continued to fall in love.

For each sticker story, or "stuck assembly," we would scan the stickers at a ridiculously high resolution (1200 dpi, RGB scan, no filter, no color correction, 100 percent scale). Honesty is key here; we would start with the truest, flattest, least appealing color source, then would apply levels and adjust colors to taste, treating each scene's color and contrast as if it were theater lighting—slightly over the top and garish. The resulting story, or "stuck assembly," would be printed onto photo paper and mounted to Letramax 2000 Superblack.

Mean Gene

Crusher

Foon Twa!

Bachelor Party

Lazy Panda

Lost Your Head?

Bad Girl

Fireman

Candy Sea 2

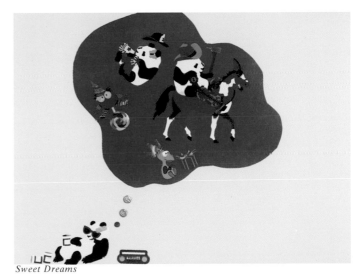

Sweet Dreams

Gotcha

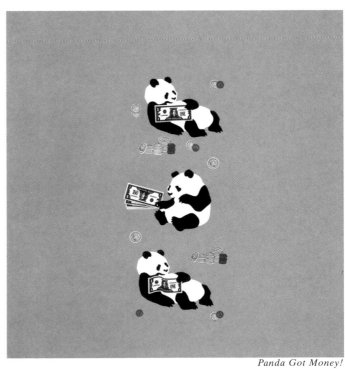

Panda Got Money!

Studio: *Spunk*
Art direction: *Jeff Johnson*
Design/Illustration: *Jason Walzer, Charlie North, Jeff Johnson,*
Steve Jockisch, and David Buck
Photography: *Jason Walzer, Charlie North, and Jeff Johnson*
Client: *Independent project*
Year: *2002*

PAUL SAHRE is a graphic designer, author, and educator whose work explores the divergence between design and art. He handprints posters for nonprofit institutions, such as the Fells Point Corner Theatre in Baltimore and the SoHo Repertory Theatre in New York. He also designs book covers for such publishers as Beacon Press, Knopf, Vintage, Little Brown, and Verso. Sahre teaches graphic design and typography at Parsons School of Design and the School of Visual Arts, both in New York City. He also oversees his own design office in New York City. He received both a B.F.A. and an M.F.A. in graphic design from Kent State in Ohio.

Sahre's work has been featured in numerous design publications, and he is the coauthor of two books, *Fresh Dialogue 1: New Voices in Graphic Design* (Princeton Architectural Press, 2000), which documents AIGA's Fresh Dialogue lecture series, and *Hello World: A Life in Ham Radio* (Princeton Architectural Press, 2003), a discussion of the history and culture of amateur radio.

Harry Mulisch

THE PROCEDURE

A NOVEL BY THE AUTHOR OF *The Discovery of Heaven*

The Procedure cover

In *The Procedure*, two men who live four hundred years apart each try to create life but fail, both suffering similar punishments for their hubris. The arm on the cover is a reproduction of the dirt cast sculpture *Hand Series #4*, by artist James Croak.

Studio: *Office of Paul Sahre*
Creative direction: *Paul Buckely*
Art direction/Design: *Paul Sahre*
Client: *Viking*
Year: *2001*

Breaking into Print cover

This is a collection of famous authors' first fiction as it appeared in the prizewinning journal *Ploughshares*. We punched a hole through a book, then photographed it.

Studio: *Office of Paul Sahre*
Creative direction: *Sara Eisenman*
Art direction/Design: *Paul Sahre*
Photography: *Michael Northrup*
Client: *Beacon Press*
Year: *2000*

Breaking into Print

Early Stories and Insights into Getting Published

A Ploughshares Anthology

Edited by DeWitt Henry

Carolyn Chute
Carolyn Ferrell
Sue Miller
Howard Norman
Tim O'Brien
Jayne Anne Phillips
Mona Simpson
and others

DEMONOLOGY

STORIES BY

RICK MOODY

AUTHOR OF
The Ice Storm AND *Purple America*

NATIONAL BESTSELLER

"Bold and thrilling....Rick Moody has spirit and drive and talent to burn."—*New York Times Book Review*

Demonology cover

Many of the stories in *Demonology* have death or violence at their center. The title piece is part nostalgic trick-or-treat, part sobering meditation on the life and death of the protagonist's sister. Other tales include an account of a drive-by shooting at a McDonald's and a narrative about the inner workings of a budget wedding palace. On the cover, the levitating Smarties reflect the mood of the title story, making something innocent creepy, while also suggesting a "collection." The Smarties were lifted with a wire, which was later deleted in Photoshop.

Studio: *Office of Paul Sahre*
Art direction/Design: *Paul Sahre*
Photography: *Michael Northrup*
Client: *Little Brown*
Year: *2002*

It's How You Play the Game cover

This is the story of a twenty-something man's trip through love and relationships. The game pieces were made by photographing models, then constructing the game pieces, arranging them, and photographing them again.

Studio: *Office of Paul Sahre*
Creative direction: *John Fulbrook*
Art direction/Design: *Paul Sahre*
Photography: *Michael Northrup*
Client: *Scribner*
Year: *2001*

It's How You Play the Game

A Novel

Jimmy Gleacher

GARDEN STATE **RICK MOODY**
A NOVEL BY THE AUTHOR OF *Demonology* AND *The Ice Storm*
"Impressive.... An auspicious debut." —*New York Times Book Review*

Garden State cover

This novel follows a group of friends in Haledon, New Jersey. The friends are out of school, trying to start a band and find work, looking for something to do. The cover was designed as part of a series (see *Demonology*, page 111, and *The Ice Storm*, opposite). As such, it needed to feature an object that was not only related to the story, but also had a conceptual twist. In this case, the cigarette butts, meant to suggest sprouting plants, also represent the characters in the book. The butts were arranged, then photographed on a seamless yellow background.

Studio: *Office of Paul Sahre*
Art direction: *Paul Sahre*
Design: *Paul Sahre and Cédric Suming*
Photography: *Michael Northrup*
Client: *Little Brown*
Year: *2002*

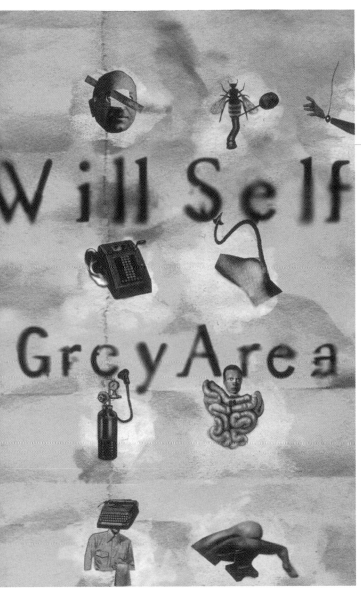

Grey Area cover

Grey Area is a book of darkly funny short stories by Will Self. Each of the collaged images on the cover–a ruler, an anvil, a toilet float, a typewriter, and an adding machine–represents one of the book's stories. The illustration was a combination of traditional collage and manipulation in Photoshop.

Studio: *Office of Paul Sahre*
Creative direction: *John Gall*
Art direction/Design: *Paul Sahre*
Illustration: *David Plunkert*
Client: *Grove Atlantic*
Year: *1997*

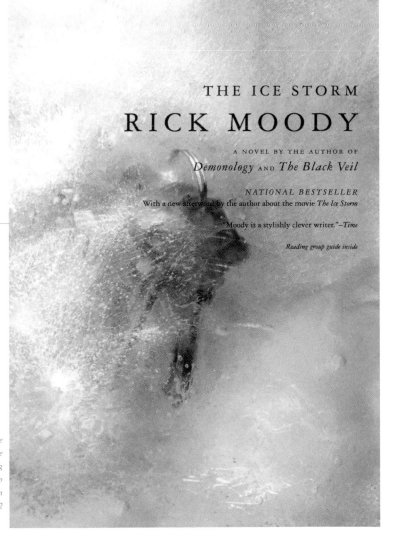

THE ICE STORM
RICK MOODY

A NOVEL BY THE AUTHOR OF
Demonology AND *The Black Veil*

NATIONAL BESTSELLER
With a new afterword by the author about the movie *The Ice Storm*

"Moody is a stylishly clever writer."–*Time*

Reading group guide inside

The Ice Storm cover

The Ice Storm is a novel set in a 1970s Connecticut suburb, where a freak winter storm serves as catalyst for a peeling back of the suburban veneer. This cover was designed as part of a series (see *Demonology*, page 111, and *Garden State*, opposite), and, as with the others, needed to feature an object that was related to the story as well as have a conceptual twist. The keys tie into the book's notorious "key party," at which married couples drop their house keys into a bowl; at the end of the night, each woman selects a pair of keys to determine who will spend the night with her. The ice suggests the literal ice storm as well as the suburb's chilly emotional facade. The photographer's house keys were frozen in a block of ice, then photographed.

Studio: *Office of Paul Sahre*
Art direction: *Paul Sahre*
Design: *Paul Sahre and Cédric Suming*
Photography: *Michael Northrup*
Client: *Little Brown*
Year: *2002*

graphicHAVOC: aVISUALagency

GRAPHIC HAVOC: AVISUALAGENCY is a company, a collective of five, working within the overlap of art and design. The studio's interest lies in the exploration of the collaborative process and its effects on design projects done for clients as well as fine-arts outlets. All projects begin with the five individuals within Graphic Havoc—Sadek Bazaraa, Randall J. Lane, Derek Lerner, David Merten, and Peter Rentz—and, in the case of design, branch out to clients and other outside entities. Each member of Graphic Havoc pursues his or her own individual artistic goals, then brings that experience to bear on the collaborative projects within the framework of the company.

Studio: *Graphic Havoc: avisualagency*
Art direction/Design: *Graphic Havoc: avisualagency*
Client: *Graphic Havoc: avisualagency*
Year: *2002*

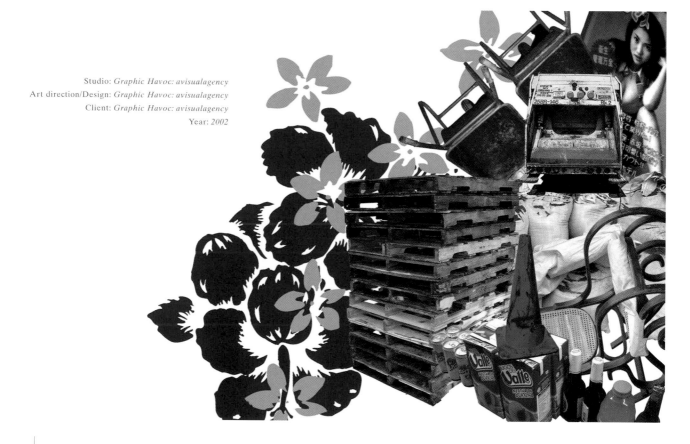

555 SOUL/Graphic Havoc invite

This invitation was created for the opening of a Graphic Havoc installation at the 555 Soul store in New York City. The installation featured shrink-wrapped found objects, large-format vinyl wall graphics (similar to those shown on the invitation), and hand-drawn illustrations applied to existing 555 bags and t-shirts.

The images used for the invitation—chosen to reflect the feel of urban life—were photos of random objects found along the street, both in Tokyo and New York. Each object was scanned and isolated from its background. The images were then collaged together in Photoshop with additional vector graphics created in Illustrator.

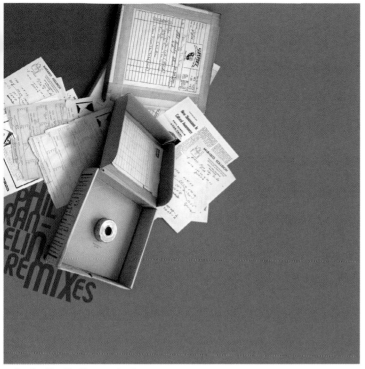

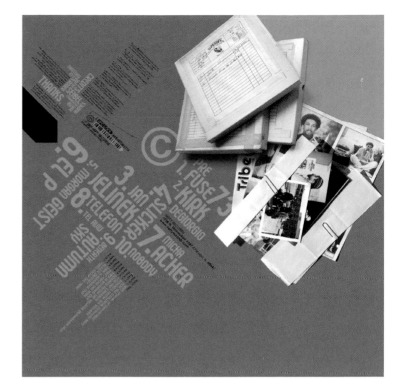

Studio: *Graphic Havoc: avisualagency*

Art direction/Design: *Graphic Havoc: avisualagency*

Client: *Hefty Records*

Year: *2002*

Phil Ranelin: Remixes LP

Found photos and source materials were gathered from jazz master Phil Ranelin's original releases for the object collage used in this remix album of his late 1960s early '70s music.

Groups of objects were arranged and photographed together for the cover collage. The different photos were then scanned in and isolated from their backgrounds to create the final composition. An awkward sense of space and perspective was created by taking the original photographs from different angles.

Dodge Magazine

Graphic Havoc designed this spread for the second issue of *Dodge Magazine*, which was organized around a theme of found objects. Each designer featured in the issue was free to display his or her interpretation of this theme.

The photos used in our spread were taken of objects "found" within a couple block radius of Graphic Havoc's studio. Each object was scanned and isolated from its background. The images were then collaged together in Photoshop with additional vector graphics created in Illustrator and other hand-drawn elements. By isolating and then juxtaposing these elements, we were working rather haphazardly and subconsciously to create an interesting design as well as to hopefully raise questions about the design's meaning. In the end, the piece became a representation of our surroundings.

Studio: *Graphic Havoc: avisualagency*

Art direction/Design: *Graphic Havoc: avisualagency*

Client: *Graphic Havoc: avisualagency*

Year: *2002*

Studio: *Graphic Havoc: avisualagency*
Art direction/Design: *Graphic Havoc: avisualagency*
Client: *Design Is Kinky*
Year: *2002*

Permanent

This spread was created for *Permanent*, a book put together by the DIK (Design Is Kinky) design collective to showcase the work of designers from around the world. The photo used is a Polaroid that was found on the walk to work one day, which then inspired the accompanying illustration. The photo was simply scanned in, as is, and was accompanied by the supporting illustration created in Illustrator.

Prefuse 73 poster

This poster was created using artwork from the *Prefuse 73 Caro: Estro* EP, which had itself used photos of found objects. The poster was designed to work as the press sheets from the *Prefuse 73 Caro: Estro* EP. The photos were treated as high-contrast black-and-white images by using several iterations of half-toning with both analog (fax machine) and digital (Photoshop) methods.

Studio: *Graphic Havoc: avisualagency*
Art direction/Design: *Graphic Havoc: avisualagency*
Client: *Warp Records*
Year: *2001*

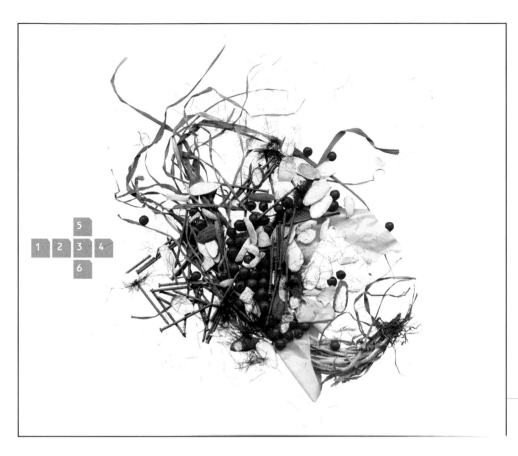

Studio: *Graphic Havoc: avisualagency*
Art direction/Design: *Graphic Havoc: avisualagency*
Client: *Hefty Records*
Year: *2000*

Slicker: Remixes LP

On this album cover for the group Slicker, each artist was represented graphically by a specific found object and color code. The objects, such as berries and hair, were gathered randomly and placed directly on the scanner. Each was then isolated from its background in Photoshop, and placed on an alternate background to form an abstract representation for each artist on the album. The main image for the cover was a direct scan of all the objects piled together to represent the idea of "remix."

CARLOS SEGURA was born in Cuba and came to the United States in 1965 at the age of nine. He grew up in Miami, where at a very young age (twelve) he joined a band as their drummer. One of his responsibilities was promotions, and when he left he used the work he'd done with the band to get his first job as a production artist—for an envelope company, designing the return addresses for bank deposit envelopes. His first real break was at an agency in New Orleans. In 1980, he moved to Chicago, where he'd always wanted to live because he liked the way the name sounded. For the next eleven years, he worked for advertising agencies in Chicago and Pittsburgh, including Marsteller, Foote Cone & Belding; Young & Rubicam; Ketchum; and DDB Needham. Segura eventually realized that he was not happy creatively, so he quit and in 1991 started Segura Inc., with the goal of blending as much "fine art" into "commercial art" as possible. In 2000 Segura Inc. was split into two dedicated companies, the second being Segura Interactive.

In 1994, Segura created the [T-26] digital type foundry to explore the typographical side of the business. [T-26] is now distributed throughout the world.

In 1996, Sagura started the independent record label THICKFACE, with its first release entitled *Mobile*, by Deep. Subsequent releases include *Aquagirl*, by Everplastic; *Revolution*, by Sister Machine Gun; self-titled albums from Micronaut, EVL, Ecohed, and Jive Council; *Slinky*, by Micronaut; and *Project*, by Sugar Cane.

In September 2001, Segura and his wife, Sun, launched www.5inch.com to sell their products online.

Chopstick EPS collection

This collection of images from fifty-one chopstick bags was self-produced as an independent project. We collected the bags from various Asian restaurants, then re-created the images in Adobe Illustrator.

Studio: *Segura Inc.*
Art direction/Design: *Carlos Segura*
Illustration: *Carlos Segura*
Client: *[T-26]*
Year: *2002*

30x40

Chunk EPS set

For this self-produced collection, intended to document items normally ignored in our daily lives, we created artwork from "chunks" of found elements. All illustrations were re-created in Adobe Illustrator.

Studio: *Segura Inc.*
Art direction/Design: *Carlos Segura*
Illustration: *Carlos Segura*
Client: *[T-26]*
Year: *1997*

Polaroid calendar

We wanted to create a calendar using numbers "found" in Chicago. The numbers were gathered in various areas of the city, and shot with a Polaroid. We scanned the photographs, converted them to digital files, then used them to build the calendar.

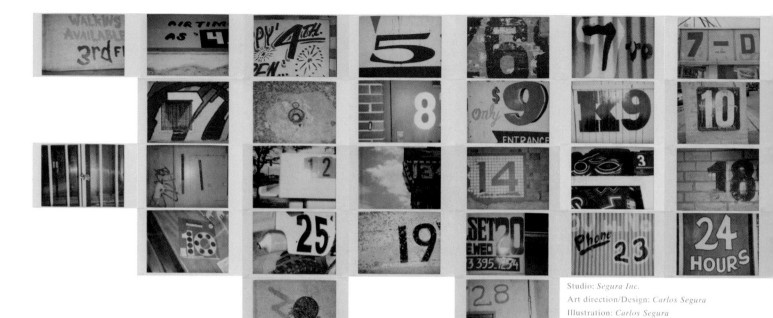

Studio: *Segura Inc.*
Art direction/Design: *Carlos Segura*
Illustration: *Carlos Segura*
Client: *[T-26]*
Year: *1998*

i repeated this page by accidenbt.

Error EPS set

This collection of postscript art was made by re-creating actual postscript "errors" encountered in our daily work. When an error occurred, art would be created from it in Adobe Illustrator, and a collection was built.

```
******************************
***    ERROR TX REPORT    ***
******************************
```

Sorr for the typos...I was in a hurry.

DOCUMENT JAM

Studio: *Segura Inc.*
Art direction/Design: *Carlos Segura*
Illustration: *Carlos Segura*
Client: *[T-26]*
Year: *1998*

Actual men's urinal filters inspired this font, produced for [T-26]. Photos were taken after extensive beer-drinking and peeing. The art was created after the hangover had passed.

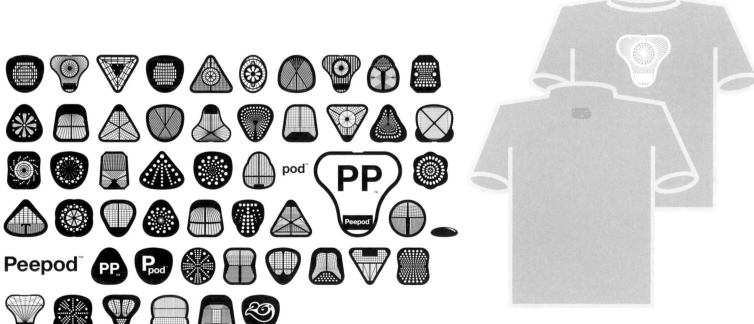

Studio: *Segura Inc.*
Art direction/Design: *Carlos Segura*
Illustration: *Carlos Segura*
Client: *[T-26]*
Year: *2000*

rideSTUDIO

Founded in southern California in 1987 by Scott Clum, RIDE STUDIO grew out of Clum's days as a skateboarder and professional snowboarder. His desire to stay in the moment, to capture a sense of strong design and mood, led to a focus on action sports, which remain areas of concentration for the studio. With its strong foundation in aesthetics, ride studio takes a unique approach, using the essence of each situation to draw its design sensibilities.

Scott Clum began as art director (and professional team rider) for Sims Snowboards. In 1990, he cofounded Morrow Snowboards, where he served as creative director from 1990 to 1995. In 1992, he cofounded *Bikini Magazine* with Marvin Jarrett (the publisher of *Raygun*), working as design director until 1994. Another project with Jarrett was *Stick Magazine*, a snowboarding publication founded by the two in 1997; Clum also did the prototype design for Jarrett's *Nylon Magazine* in 1999.

Now headquartered in Salem, Oregon, ride studio has received numerous design awards, including those from the Type Directors Club, *Graphis*, the American Center for Design's 100 Show, and the Art Directors Club (New York City). The studio's work is also part of the Cooper-Hewitt National Design Museum's permanent collection.

Extreme Design book cover

Working with Spencer Drate is always a free-form exercise. This is a compliment—he lets the artist do his or her thing, then stands back and appreciates it. For this project, it was up to me to understand what "extreme design" was. I'm not sure now whether I do or not, but at the time it meant taking a closer look to find the imagery in my surroundings—in this case, brier stems.

The brier stems were shot on both Polaroid and 35mm Fuji film for a green color base. Once the stems were shot, we composed them in as natural a way as possible and cropped in on the details. The idea of one-dimensional type didn't fit with the idea of the brier, so the type was treated the same way as the organic setups. The idea was extreme to me, as we used a unique starting point for a commercial book cover.

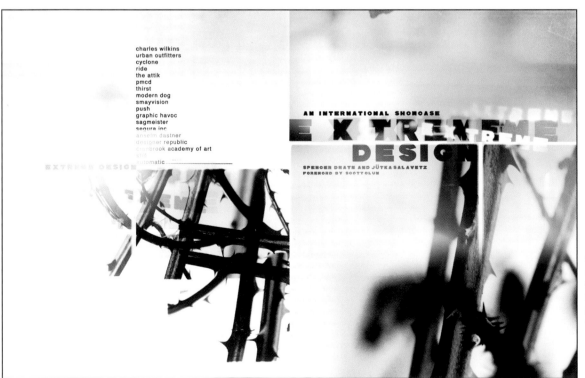

Studio: *ride studio*
Art direction/Design: *Scott Clum*
Illustration: *Kent Williams*
Client: *HOW Design Books/ Spencer Drate*
Year: *2002*

In This Heart short video

Kent Williams and I have long sent faxes and notebook illustrations back and forth to each other. Kent had sent me some basic elements last fall and I fell in love with their unique, raw qualities. I began picturing a motion to the illustrations; I wanted to work on a minimalist level with just raw forms of illustration, to see how they could tell a story.

I put the illustrations in order based on Kent's notebook ideas. The images were layered and relayered to form stronger content and to push each image to the next level. Once the completed frames were ready, they were brought into After Effects and recomposed once more. Final backgrounds were added and speeds adjusted. Although the idea remained underdeveloped, the imagery worked well in telling the notebook story. The movie was never intended to be finished but rather remain a work in progress, like a notebook.

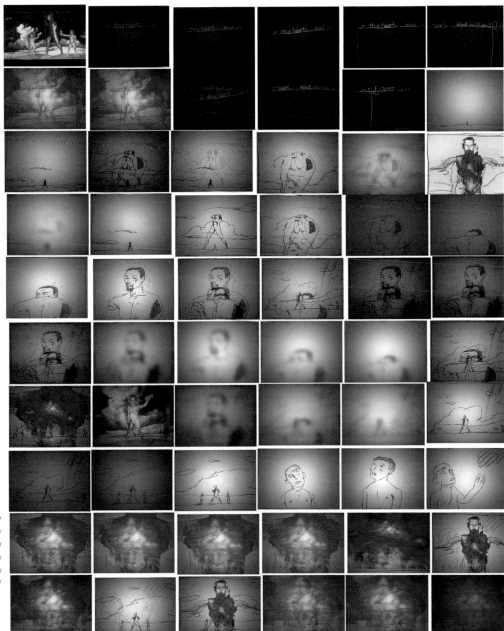

Studio: *ride studio*
Art direction: *Scott Clum and Kent Williams*
Design: *Scott Clum*
Illustration: *Kent Williams*
Client: *Kent Williams and Scott Clum*
Year: *2001*

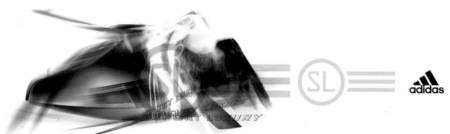

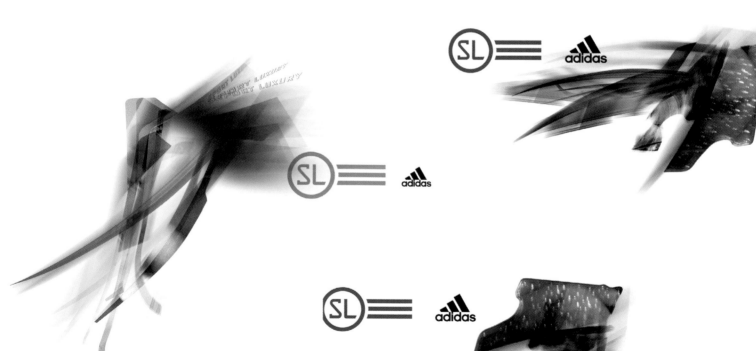

adidas shoe composites

The main idea behind these works was to explore individual sections of the shoe. I re-created each piece with found objects and recomposed the shoe into a more organic product/illustration. The intent was to shed a different light on form and shape and visually restate the shoe.

The found objects used included photographs and various textures, which were scanned into Photoshop and layered. Some pieces were used as masks, others were used as the specific texture, and as building components of the new form.

Studio: *ride studio*
Art direction: *Scott Clum*
Design: *Scott Clum and Adam Royer*
Client: *adidas*
Year: *2001*

Studio: *ride studio*
Art direction/Design: *Scott Clum*
Client: *Golden Artist Colors*
Year: *2002*

Golden ten-panel sales piece

Golden Artist Colors is a fine-arts manufacturer with a reputation for making the finest artist materials available for both professionals and beginners. Golden's factory is in a beautiful setting, amongst the hills of upstate New York, and when we went there to discuss the job it became quickly apparent that this location and its heritage of building and equipment had to be parts of the piece.

The entire piece was shot in natural light on a Yashika-D 2 1/4-format camera, which I chose for its lens and its ability to capture romantic sensibilities. All photographs remained untouched in Photoshop, and were printed true to the atmosphere of the plant. We were thus able to show the company's capabilities as well as express its fine-art approach to artist materials.

ELLIOTT EARLS is designer-in-residence and head of the 2-D Design Department at Cranbrook, the only graduate school in the United States dedicated to fine arts education. Upon graduation from Cranbrook in 1993, Earls's experimentation with nonlinear digital video, spoken word poetry, music composition, and design led him to form the Apollo Program.

Earls's original type design is distributed worlwide by Emigre Inc. His posters *The Conversion of Saint Paul, Throwing Apples at the Sun, The Temptation of Saint Wolfgang,* and *She's a Capulet* are part of the permanent collection of the Cooper-Hewitt National Design Museum.

In May 2002, in association with Emigre Inc., Earls released *Catfish*, a fifty-five minute film on DVD. *Catfish* traces Earls's work from the lab to the stage in a highly manipulated digital film, incorporating animation, stop-motion photography, drawing, typography, and live action into a seamless performance documentary.

From September 2000 until May 2001, Earls worked as a designer in residence at Fabrica, Benetton's research center in Treviso, Italy. In 2001 he was a finalist for the Chrysler National Design Award in New Media. As a performance artist, he was awarded an Emerging Artist grant by New York's prestigious Wooster Group. Earls was profiled in 2002 by *Eye, Print,* and *Punk Planet* magazines.

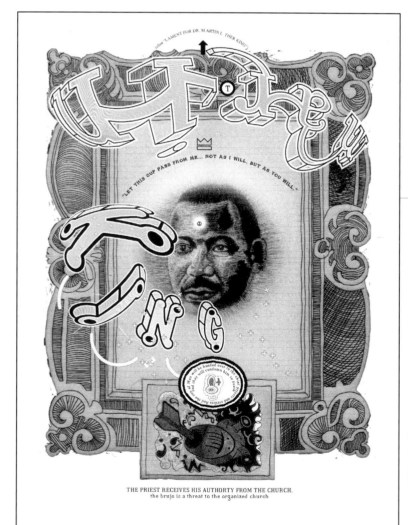

THE PRIEST RECEIVES HIS AUTHORTY FROM THE CHURCH.
the brujo is a threat to the organized church

Pages from Elliott Earls' "No Hero" series for Emigre magazine

I produced a series of portraits for *Emigre* magazine that focused on the paradoxical idea of "no hero," a belief that one should not have heroes. Historically significant characters such as Max Ernst, Martin Luther King, Malcolm X, and Kurt Schwitters were featured. All of the designs and faces were etched onto found objects, such as old pieces of linoleum. The etchings were then scanned into the computer and manipulated to produce the final page layout.

Studio: *The Apollo Program*
Art direction/Design:
Elliott Earls
Client: *The Apollo Program*
Year: *2001*

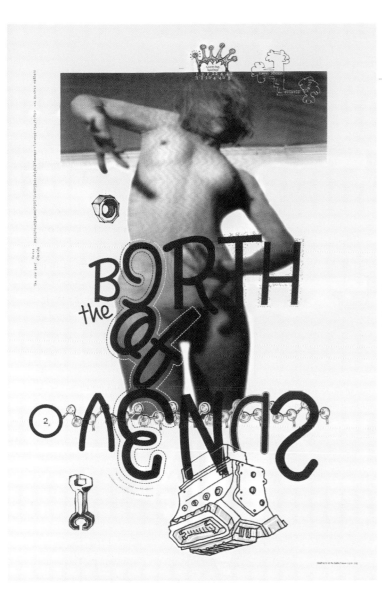

This promotional poster for the Apollo Program was originally produced to announce the release of my typeface Venus Dioxide. The found object was the actual camera used for the main photograph. While in a junk store in Detroit I found an old Polaroid that was in terrible condition. It takes the most beautiful photographs. The photo was manipulated to seamlessly combine with drawn elements.

Studio: *The Apollo Program*
Art direction/Design: *Elliott Earls*
Client: *The Apollo Program*
Year: *1998*

AIGA Fresh Dialogue poster

I designed this poster for AIGA's New York chapter. Found Kanji pictograms were used as the basis for a digital collage process. The images were scanned, then manipulated in Photoshop. The goal was to create very high-contrast images, which could then be combined seamlessly in Freehand with typography and drawings.

Studio: *The Apollo Program*
Art direction/Design: *Elliott Earls*
Client: *The Apollo Program*
Year: *2001*

Stills from Eye Sling Shot Lions performance

These are stills from my recent performance piece, entitled *Eye Sling Shot Lions*. In it, homemade electronics communicate with projected video via MIDI messages.

Ductwork from Home Depot was fashioned into MIDI drums with cheap piezio electric discs from Radio Shack. The ductwork drums sent signals to the computer, which manipulated the video onstage.

Studio: *The Apollo Program*
Art direction/Design: *Elliott Earls*
Client: *The Apollo Program*
Year: *2000*

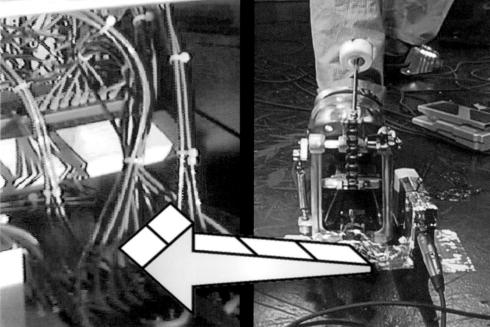

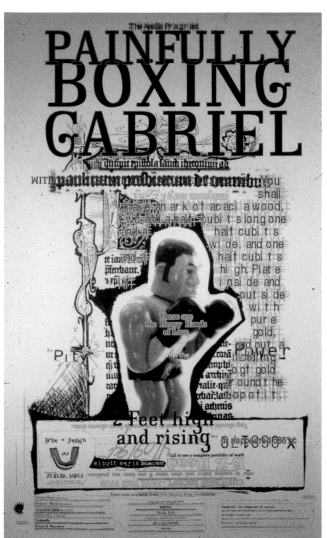

Painfully Boxing Gabriel

This promotional poster for the Apollo Program was originally produced to announce the release of my typefaces Calvino Hand and Subluxation. The poster was designed after finding and photographing a Rock'm Sock'm Robot toy. The poster was created through a simple digital photomontage process, utilizing Freehand and Photoshop to composite drawings and photos.

Studio: *The Apollo Program*
Art direction/Design: *Elliott Earls*
Client: *The Apollo Program*
Year: *1997*

The Conversion of Saint Paul

This promotional poster for the Apollo Program was originally produced to announce the release of my typefaces Mothra Paralax and Subluxation. After finding a very odd sample of kanji (Japanese ideographic characters), I redesigned the Japanese character set to function like our modern English alphabet, by adding strokes to the kanji. This made it possible to read the kanji as English. The type was then incorporated into a poster.

Studio: *The Apollo Program*
Art direction/Design:
Elliott Earls
Client: *The Apollo Program*
Year: *1999*

Spencer Drate and Jütka Salavetz have been art directing and designing as a team in the areas of music packaging, book design, and logo identity for more than two decades. Some of their clients include Lou Reed, U-2, Talking Heads, Bon Jovi, the Ramones, the Velvet Underground, Joan Jett, Paul McCartney, and the Beach Boys.

Drate and Salavetz have authored and packaged numerous books, including *Rock Art: CDs, Albums & Posters* (PBC International, 1993), *Cool Type* (North Light Books, 1997), *Cool Type 2wo* (North Light Books, 1999), *Extreme Fonts: Digital Faces of the Future* (Madison Square Press, 1999), *Web Art: A Collection of Award Winning Web Art Designers* (Madison Square Press/Watson-Guptill Publications, 1999), *Extreme Design* (HOW Design Books, 2001), *45 RPM: A Visual History of the Seven-Inch Record* (Princeton Architectural Press, 2002), and *Swag: Rock Posters of the '90s* (Abrams, 2003). They have won many design awards, including a 1993 Billboard Award for best retail poster of the year and several Art Directors Club and AIGA awards.

Drate and Salavetz were selected for the Cooper-Hewitt National Design museum's Mixed Messages exhibition and have been interviewed in major media, such as VH-1 and MTV.

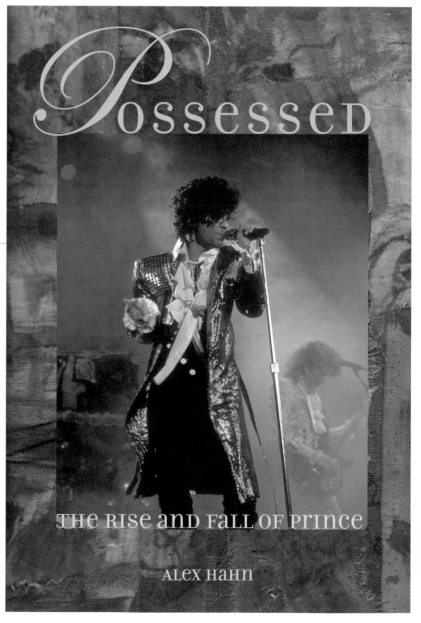

Possessed: The Rise and Fall of Prince book cover

The concept for this cover was to evoke the feeling of Prince's romantic/rock/Renaissance image. Background art was created as a collage from painted silk pieces glued onto a small canvas.

The silk pieces were remnants from a friend, who used to paint on silk fabric for the purposes of making pillows and special-order clothing. She normally discarded these pieces, but I [Judith] thought they were much too beautiful to throw out and would collect them from her cutting-room floor. My plan was to create a huge piece of canvas. Unfortunately, the friend stopped painting silk fabrics, thus putting an end to the idea of a huge canvas. I did, however, have enough to create a small canvas, in which I immediately saw the potential for the background of this cover.

Art direction: *Sharon Kaplan*
Design: *Jütka Salavetz and Spencer Drate*
Photography: *David Seelig/Star File*
Client: *Billboard Books*
Year: *2003*

The Velvet Underground Live MCMXCIII retail poster

The image on this poster came from the original *The Velvet Underground and Nico Album* cover, designed by Andy Warhol. The concept evolved into a metallic banana image for the retail and limited-edition special-package CDs.

A banana was modeled in clay and covered in foil, then burnished and photographed. The title, "The Velvet Underground," was composed of plastic lowercase letter pieces glued to a board, which was then covered with foil and burnished. Velvet material was photographed for the background. All photographed images were then scanned and pieced together in Photoshop.

Art Direction/Design: *Sylvia Reed, Spencer Drate, Jütka Salavetz, and Dennis Ascienzo*
Photography: *Ted Chin*
Client: *Sire/Warner Bros. Records*
Year: *1993*

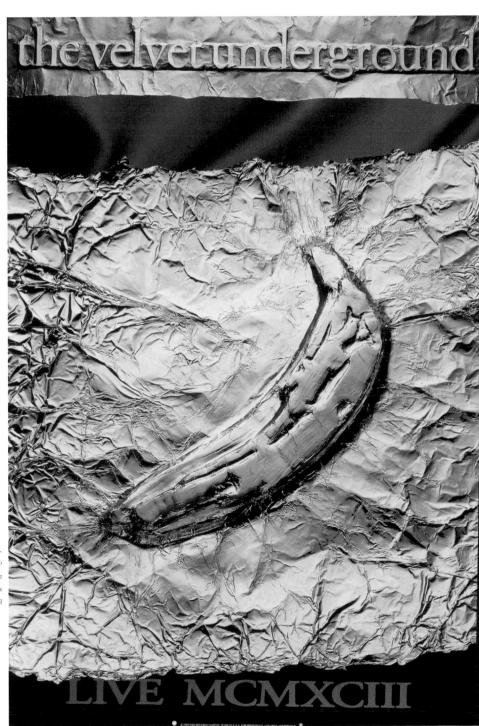

WOODEN CHOPSTICKS

DIRECTORY

Ames Design
1735 Westlake Avenue N., Suite 201
Seattle, WA 98109
tel: 206/516.3020
fax: 206/633.2057
ames@speakeasy.net
www.amesbros.com
www.bigpopposters.com

Ashby Design
667 S. Washington Street
Alexandria, VA 22314
tel: 703/549.4909
fax: 703/549.5790
info@ashbyandassociates.com
www.ashbyandassociates.com

BOYZandGIRLS DESIGN
60 Avenue B, Suite 2D
New York, NY 10009
tel: 212/260.8764
ans@inch.com
www.boyzandgirls.com

Chase Design Group
2255 Bancroft Avenue
Los Angeles, CA 90039
Tel. 323/668.1055
Fax: 323/668.2470
info@chasedesigngroup.com
www.margochase.com

Cream01 Federation
Wittelsbacherstrasse 17
80469 Munich
Germany
tel: +49/89.729.8960
fax: +49/89.729.89629
www.cream01.com

Stephen Doyle
Doyle Partners
1123 Broadway
New York, NY 10010
tel: 212/463.8787
fax: 212/633.2916
doyle@doylepartners.com

Spencer Drate
160 Fifth Avenue, Room 905
New York, NY 10010
tel: 212/620.4672
fax: 212/727.1322
spencerdrate@yahoo.com

Elliott Earls
The Apollo Program
c/o Cranbrook Academy of Art
P.O. Box 801
Bloomfield Hills, MI 48303
tel: 248/645.3083
elliott@theapolloprogram.com
www.theapolloprogram.com

Stephen Farrell
Slipstudios
4421 North Francisco Avenue
Chicago, IL 60625
tel: 773/279.0979
slipstudios@compuserve.com
www.slipstudios.com

Firehouse 101 Art & Design
641 N. High Street, Suite 106
Columbus, OH 43215
tel: 614/464.0928
fax: 614/464.0200
fn101@ee.net
www.firehouse101.com

Michael Garson
29 1/2 Brooks Avenue, #B
Venice, CA 90291
tel: 310/871.5996
design@garson.net
www.garson.net

Maria Gaviria
Chase Design Group
2255 Bancroft Avenue
Los Angeles, CA 90039
tel: 323/668.1055
fax: 323/668.2470
maria@chasedesigngroup.com
www.margochase.com

Alexander Gelman
Design Machine
648 Broadway
New York, NY 10012
tel: 212/982.4289
fax: 212/982.1260
inbox@designmachine.net
www.designmachine.net

Graphic Havoc: avisualagency
184 Kent Avenue, Suite 311
Brooklyn, NY 11211
tel: 718/388.5519
fax: 718/387.7383
info@graphichavoc.com
www.graphichavoc.com

Groundzero
160 Fifth Avenue, Suite 914
New York, NY 10010
tel: 212/627.4088
start@groundzero.com
www.groundzero.com

Jeff Johnson
Spunk
718 Washington Avenue N., Suite 507
Minneapolis, MN 55401
Tel: 612/904.0541
spunk@bitstream.net
www.spunknation.com

Chip Kidd
Knopf
1745 Broadway, 19th floor
New York, NY 10019
tel: 212/572.2363
fax: 212/940.7676
ckidd@randomhouse.com

Jeff Kleinsmith
6708 9th Avenue NW
Seattle, WA 98117
tel: 206/441.8441 ext. 3030
fax: 206/441.0474
jeff@thepatentpending.com
www.patentpending.com

Viktor Koen
310 E. 23rd Street, Suite 10A
New York, NY 10010
tel: 212/254.3159
viktor@viktorkoen.com
www.viktorkoen.com

Pablo Medina
Cubanica
285 West Broadway, Room 280
New York, NY 10013
Tel: 800/615.3533
info@cubanica.com
www.cubanica.com

Ride Studio
331 Bush Street, S.E.
Salem, OR 97302
tel/fax: 503/375.9019
www.ridestudio.com

Brian Roettinger
24445 Lisa Kelton Place
NewHall, CA 91321
tel: 661/917.5294
nowavekid@aol.com
www.dimmak.com/h3/

Stefan Sagmeister
Sagmeister Inc.
222 W. 14th Street
New York, NY 10011
tel. 212/647.1789
fax: 212/647.1788
ssagmeiste@aol.com

Paul Sahre
Office of Paul Sahre
536 6th Avenue, 3rd floor
New York, NY 10011
tel: 212/741.7739
fax: 212/741.7859
paul@officeofps.com

Jütka Salavetz
Hell's Kitchen Design
517 West 45th Street, Suite 403
New York, NY 10036
tel/fax: 212/397.7996
jsalavetz@nyc.rr.com

Carlos Segura
Segura Inc., Segura Interactive,
and [T-26] Digital Type Foundry
1110 North Milwaukee Avenue
Chicago, IL 60622
tel: 773/862.1201
fax: 773/862.1214
for [T-26] Digital Foundry:
 info@t26.com
 www.t26.com
for Segura, Inc.:
 info@segura-inc.com
 www.segura-inc.com
for Segura Interactive:
 www.segurainteractive.com

Slow Hearth Studio
295 Sixth Avenue
Brooklyn, NY 11215
tel: 718/369.1089
plexie@nyc.rr.com

Smay Vision
160 Fifth Avenue
New York, NY 10010
tel: 212/691.3889
fax: 212/691.3544
smay@smayvision.com
www.smayvision.com

Spur Design
3504 Ash Street
Baltimore, MD 21211
tel: 410/235.7803
fax: 410/235.4674
info@spurdesign.com
www.spurdesign.com

Toupee
717 East 5th Street, Suite BA
New York, NY 10009
tel: 212/473.7492
noel@toupeefilm.com
www.toupeefilm.com

TWO:design
Studio 20
The Arches
Hartland Road
London NW1 8HR
England
tel: +44/(0)20.7267.1118
fax: +44/(0)20.7482.0221
studio@twodesign.net
www.twodesign.net

Charles Wilkin
Automatic Art and Design
381 Broadway, 4th floor, Suite 1
New York, NY 10013
tel: 212/226.5422
fax: 212/226.7703
info@automatic-iam.com
www.automatic-iam.com

Zinzell
228 W. Houston, Suite 4
New York, NY 10014
tel: 212/243.9805
fax: 212/243.9806 (call first)
info@zinzell.com
www.zinzell.com

Opposite: Chopstick EPS collection *(detail, rotated), designed by Carlos Segura (see also page 118)*

INDEX